opera maestra

The painter's mind ought to turn endlessy into as many discourses
as the number of those remarkable objects which appear in front of him

Mandragora s.r.l.
via Capo di Mondo, 61
50136 Florence
www.mandragora.it

Editor Marco Salucci
with Francesca Mazzotta

Translation Ruth Taylor

Art director Paola Vannucchi

Printed by Grafiche Martinelli,
Bagno a Ripoli (Florence)

Bound by Legatoria Giagnoni,
Calenzano (Florence)

Printed in Italy
May 2019

isbn 978-88-7461-410-3

Marco Versiero

Leonardo

Nature in the Mirror

Mandragora

The times of Leonardo
Chronological and biographical notes

Leonardo was born in Vinci on 15 April 1452, "at three in the night" (or, in Medieval usage, at about ten thirty at night), as noted by his paternal grandfather in his family book. According to tradition, his exact birthplace was situated in the *contrada* of Anchiano, where his father owned a farmhouse. Born illegitimate, Leonardo was initially the undesired result of an affair between ser Piero da Vinci and the servant or peasant girl Caterina, about whom little is known. The land registry entry of 1457, however, confirms the presence of the young child in his father's home, suggesting that, as the firstborn, he was regarded with particular affection.

In fact, recognising his precocious talent in drawing, sometime between 1464 and 1466 ser Piero arranged for him to enter the Florentine workshop of his friend Andrea del Verrocchio, long before moving to the city himself with the rest of his family to take up his duties as notary in Palazzo Vecchio (1469).

On 27 May 1471, Leonardo assisted and perhaps collaborated (according to a later *memorandum*) on the placing of a great copper sphere designed and executed by Verrocchio at the summit of the lantern of the Duomo in Florence. The following year his name appeared, together with that of his master, in the register of painters enrolled in the Compagnia di San Luca.

The 9 April and 7 June 1476 were dates that clouded his Florentine youth: anonymous claims had been made about sodomy and Leonardo (who resided with Verrocchio) was among those investigated. He was soon acquitted and immediately afterwards, between 1476 and 1478, must have begun to frequent the garden of San Marco under the aegis of Lorenzo the Magnificent. Perhaps introduced by Verrocchio, who is known to have worked there on the restoration of a

classical sculpture, Leonardo was thus able to appreciate and study the classical masterpieces forming part of this Medici collection *en plein air*, the only one of its kind.

His first official commissions belong to the few years before his departure from Florence: on 10 January 1478, he was assigned by the Signoria the task of taking over from Antonio del Pollaiolo the execution of an altarpiece for the chapel of San Bernardo in Palazzo Vecchio (although he failed to honour the commitment, despite receiving an advance payment of 25 florins); in March 1481, thanks to the intervention of his father, he received the commission for the *Adoration of the Magi* for the Augustinian monastery of San Donato a Scopeto, which he was nevertheless to leave unfinished the following year in the house of his friends, the Benci, when he moved to Milan. He had been sent there by Lorenzo the Magnificent as a talented musician in the context of delicate diplomatic exchanges with the Sforza, but he chose to arrive there instead with a letter of presentation in which he declared himself to be skilled in the arts of war.

On 25 April 1483 a contract was drawn up with Franciscan Confraternity of the Immaculate Conception for the execution of an altarpiece for the church of San Francesco Grande (once in the Milanese neighbourhood of Sant'Ambrogio), which has been identified as the version of the *Virgin of the Rocks* now in the Louvre. In addition, payments were already recorded in 1487 for the designs he had prepared for the completion of the lantern tower of the Duomo, in direct competition with his architect colleagues and friends Bramante and Amadeo. His success at court was almost immediate: he entertained Ludovico il Moro's entourage

with rebus, witty stories and sharp riddles, and was ready to create allegories that glorified his political greatness and extended to the directing of astonishing entertainments, such as the memorable *Festa del Paradiso* of 13 January 1490. On 23 April of that year, he began the second phase of his studies for the casting in bronze of the monumental equestrian statue of Francesco Sforza, Ludovico's father (a work he had already promised in the letter of 1482, but for which he would only manage to produce a clay model). In July, he recorded in his notes the arrival in his workshop of Gian Giacomo Caprotti da Oreno, a young apprentice barely ten years old and, with the nickname Salaì ("little devil"), destined to become his pupil and heir. He was joined in Milan on 16 July 1493 by his natural mother, who died however shortly afterwards (1494). In 1496, the branch of the Martesana canal in the inner circle of the Naviglio was inaugurated at Ponte delle Gabelle and Leonardo was responsible for the invention of the lock with opening gates for regulating the water level, near the parish of the Incoronata (still in existence today). On 9 February 1498, in his dedication of *De divina proportione* to Ludovico il Moro, the mathematician Luca Pacioli records as complete the mural painting of the *Last Supper* in the refectory of the Dominican church of Santa Maria delle Grazie. In 1499, however, dramatic changes occurred: with the looming threat of the French invasion, in August il Moro fled Milan, which was subsequently invaded the following 6 October by the Gascons, who destroyed the Sforza horse.

The artist's career was then overtaken by historical events and, having abandoned the decoration of the Sala delle Asse in the Castello Sforzesco in Milan (begun in the spring of 1498), he departed for

Mantua, where he was to remain for several months as the guest of Isabella d'Este, Ludovico's sister in law. Thus began a long period of wandering: in March 1500 he was documented in Venice, where he appears to have been engaged by the Doge to inspect the course of the river Isonzo for strategic and military purposes; in August he returned to Florence, while on 10 March of the following year he recorded his own presence "in Rome, at Tivoli Vecchio, Hadrian's house". From the summer of 1502, he entered the service of Cesare Borgia as an architect and military engineer, in the Marche and Romagna regions, receiving a travel permit on the 18th of August.

His return to Florence is documented by payments and withdrawals in his current account held at the Ospedale di Santa Maria Nuova, dated 4 March 1503. A year later, on 4 May, he signed the official contract with the Republic for the mural painting of the *Battle of Anghiari* in the Sala del Maggior Consiglio. On 30 May 1506, at the request of the French governor Charles d'Amboise, Pier Soderini nevertheless agreed to allow Leonardo to return to Milan; on 22 January 1507, at the King of France's insistence, the *gonfaloniere* reluctantly and definitively relieved the artist of his Florentine obligations.

In order to resolve a legal dispute that had arisen in the meantime with his half-brothers over the contested inheritance of his paternal uncle Francesco, Leonardo returned to Florence in the spring of 1508, where he noted on 22 March that he was the guest of Piero di Baccio Martelli. Following the death of Charles d'Amboise (1511), he accepted the protection of Giuliano de' Medici, brother of the newly-elected pope Leo X, and on 24 September 1513 he departed for Rome, where he stayed in the Vatican apartments in the Belvedere. His time there was troubled, marked by a sense of isolation, aggravated on one hand by disagreements with two German workers who thwarted his studies on parabolic burning mirrors, and on the other, by the Pope who prohibited him from proceeding with his anatomical studies, on suspicion of necromancy.

In 1517, following the death of Giuliano de' Medici (17 March 1516), François I, the new King of France, welcomed him to the Chateau de Cloux (near Amboise). With the title of 'peintre du roy', the king granted him a pension of 10 thousand *scudi*, as well as a salary for his pupils Francesco Melzi and Salaì. Leonardo

brought with him few belongings: a pile of books, some paintings, including the *Saint Anne*, in addition to *Saint John* and the *Mona Lisa*. He ignored a paralysis in his right hand, persevering in his anatomical and architectural studies, and he began to design a grandiose new palace for the king at Romorantin.

On 23 April 1519 he prophetically dictated his final will, naming his faithful follower Melzi as executor. He died on 2 May and on 12 August was buried in the church of Saint Florentin, in Amboise. However, his remains were desecrated and dispersed during the wars of religion.

Study of a bearded man, perhaps for an apostle in the 'Last Supper' (formerly thought to be a self-portrait), c. 1490–5 (?).
Sanguine on unprepared paper, 33.3 × 21.3 cm. Turin, Biblioteca Reale, inv. 15571.
Traditionally thought to be a self-portrait as an old man (around 1510 or later), in recent years the drawing has been backdated to the final decade of the Quattrocento, on technical and stylistic grounds: the still refined use of sanguine, with results that look almost engraved, as well as the shading in parallel lines leaning diagonally to the left, are characteristics typical of the use in the artist's early years of this new graphic medium (adopted in the same way as a stylus or pen), while in later years Leonardo favoured its atmospheric qualities, supported by curved strokes rather than straight ones, in the creating of form.

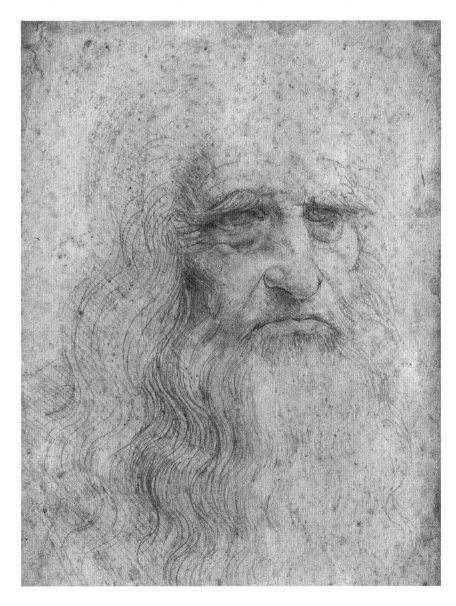

A "haphazard and extremely unpredictable" life

When the Carmelite brother Pietro da Novellara, correspondent of the marchioness of Mantua Isabella d'Este, on several occasions during the spring of 1501 visited the studio established by Leonardo in the rooms made available to him by the Servite brothers in the Florentine monastery of Santissima Annunziata, he observed that the artist led "a haphazard and extremely unpredictable life, so that he only seems to live from day to day" (letter of 3 April): "lacking the patience necessary to paint as he should", Leonardo was, in his opinion, "hard at work on geometry", to such an extent that "he has no time for the brush" (letter of 14 April). Leonardo had been Isabella's guest for several months during the winter of 1499–1500, in the wake of the Duchy of Milan's surrender following the French invasion which had also led the artist to abandon the city where he had spent almost twenty years: on that occasion, Isabella had persuaded the artist to paint her portrait, having resolved to chose him rather than Giovanni Bellini, after she was lent in 1498 by Cecilia Gallerani (who had in the meantime become countess Bergamini) the portrait Leonardo had made of her in her youth (when she was the mistress of Ludovico il Moro) and now identified as the fascinating and nonchalant *Lady with an Ermine* [**fig. 1**]. All that has survived of Isabella's much desired portrait (for which she repeatedly called on the assistance of her trusted emissaries like Novellara to plead with the volatile Leonardo) is a refined preparatory cartoon in charcoal and red chalk, with the outlines marked and pricked in preparation for pouncing to transfer it onto panel, although it was never in fact painted [**2**].

At that time, Leonardo was indeed more interested in the study of Euclidean geometry, to which he had been introduced in 1496 in Milan by the mathematician Luca Pacioli: for the Franciscan brother's treatise *De divina proportione*, published in manuscript form in 1498, he had in fact executed the drawings of the Platonic solids for the explanatory plates, eventually included in the Venetian edition printed in 1509 [**3**]. Nevertheless, Novellara himself noted the presence in his studio of an autograph cartoon for *St Anne*, as well as a "quadretino" [small painting] intended for Florimond Robertet, secretary to the King of France, Louis XII. The first work, described in the letter dated 3 April,

1. *Lady with an Ermine (Portrait of Cecilia Gallerani)*, c. 1488–90, oil on walnut panel (single board), 54.8 × 40.3 cm. Krackow, Museum Czartoryskich, inv. 134 (acquired in 2016 by the Polish State, on loan to the Muzeum Narodowe since 19 May 2017).

At the end of 1486, Ludovico il Moro was invested by the King of Naples as a Knight of the chivalric Order of St Michael, whose heraldic coat of arms was the ermine. Symbol of virtue and moderation, as it was held that it preferred to die rather than soil its own whiteness, Leonardo learnt of its significance from reading the 14th-century *Fiore di virtù*: "moderation restrains all the vices; the ermine prefers to die rather than to defile itself" (Ms H, fol. 48v). In 1487, Cecilia Gallerani was released from a previous marriage agreement and, barely fourteen years old, became Ludovico's mistress, bearing him a son, Cesare Sforza, in 1491. The Greek word used to refer to the family of mustelids to which the ermine (*galé*) belongs, is often seen as a sophisticated pun on the sitter's family name. The animal might indicate her moderate but proud elegance, in a play of reciprocal assonances, both in physiognomy and demeanour, between the untamed animal and the resolute young woman. The dating of the work should be assigned to sometime between 1489 and 1490: from then onwards, Ludovico's relations with the kingdom of Naples deteriorated, with the consequent annulment of the investiture.

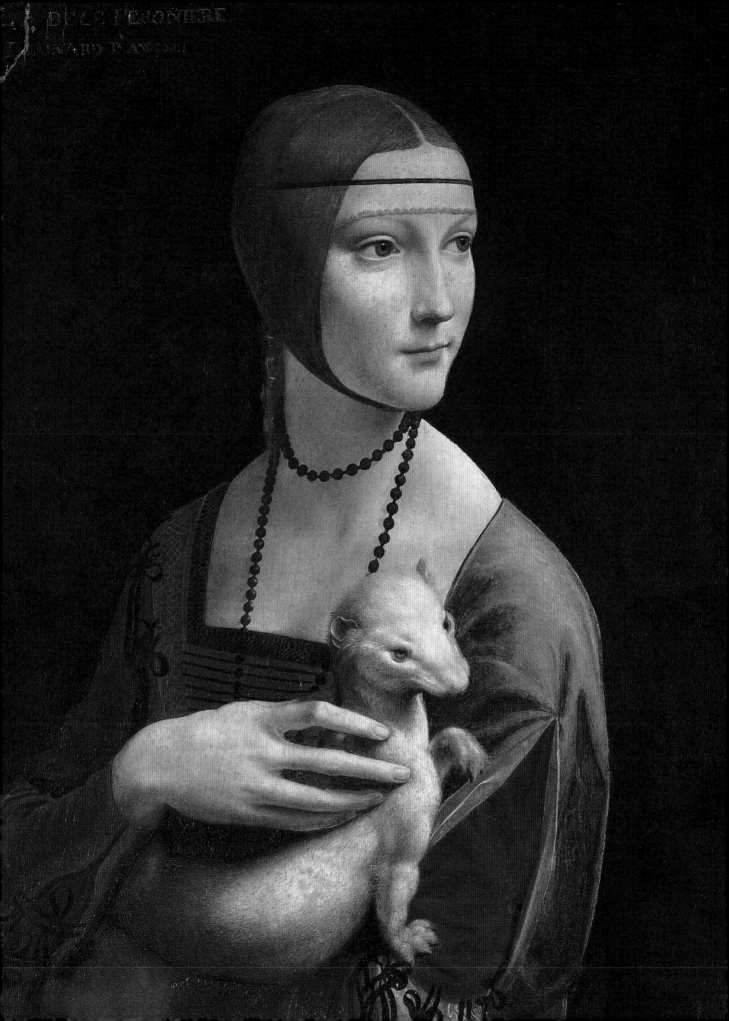

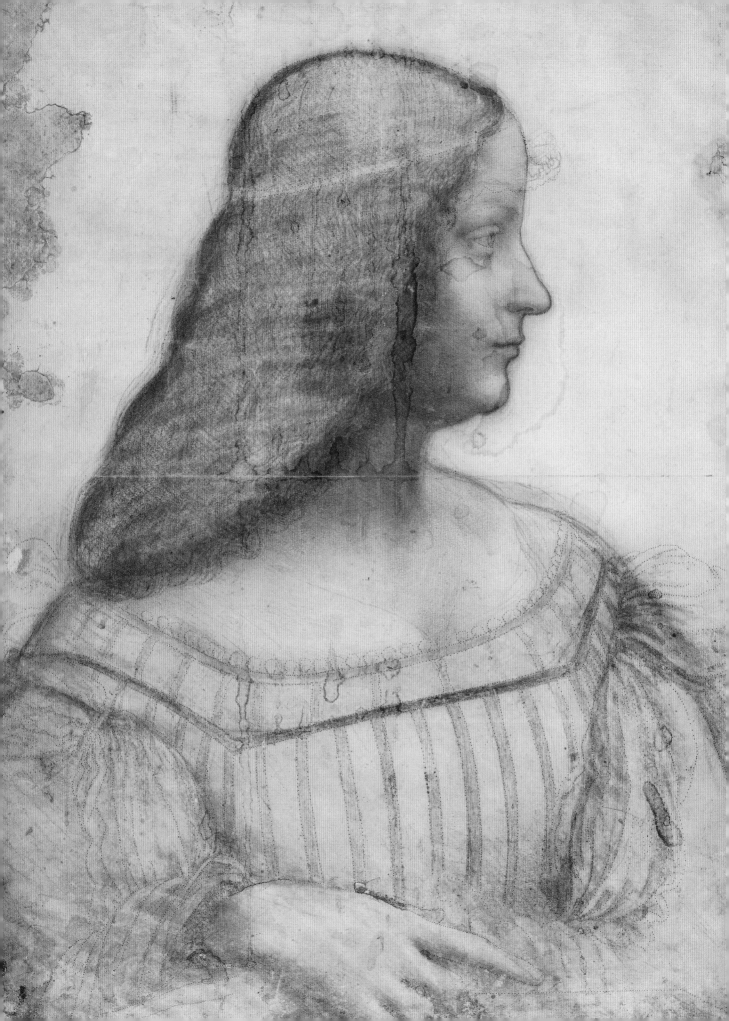

might also correspond to the cartoon whose grand display to the public in the monastery of the Annuziata itself [4] would later be recorded by Giorgio Vasari. This event aroused the enthusiasm of the Florentine population, who recognised in the mother of the Virgin one of the Republic's patron saints, since the day in which she was consecrated, 26 July 1343, marked the defeat of the duke of Athens, Gualtiero di Brienne, who had been tyrannising the city of Florence. The painting for Robertet depicted "a Madonna seated as if she were about to spin yarn" (letter of 14 April): it should, however, be considered the work of "two of his pupils" [5], merely supervised by Leonardo after providing them with one or two preparatory sketches [6].

As can be deduced from this direct testimony of Leonardo's workshop practice during his later years, painting and by extension drawing had been (and were to remain) the common denominator of all his cognitive experiences, despite the plurality of his disparate interests and the versatility of his skills, nurtured from an early age in the workshop of Andrea Verrocchio. It was there that his training in many techniques took place in the years between 1464 and 1466, during his youth in Florence, when, excluded from access to a regular course in humanist studies (having being born illegitimate on 15 April 1452), Leonardo had entered the workshop at the wish of his father, a notary. He was to remain in that flourishing environment for a decade (a document of 1476 states that he was still "with Andrea del Verrocchio"), that is to say much longer than the customary practice of about six years considered as preparatory to enrolment on the register of painters belonging to the Compagnia di San Luca (which happened in 1472).

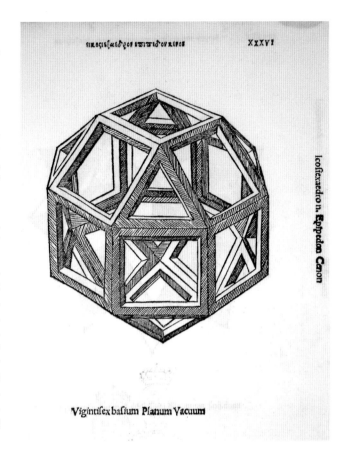

Vigintifex bafium Planum Vacuum

2. *Portrait of Isabella d'Este*, 1499–1500, **charcoal, sanguine, *sfumino*, ochre pastel, white heightening, on whitish lightly prepared paper, perforated for 'pouncing', 61 × 46.5 cm (cut below). Paris, Musée du Louvre, Département des Arts graphiques, inv. MI 753.**
On 13 March 1500, the lute-maker from Pavia, Lorenzo Gusnasco, wrote to the marchioness of Mantua that in Venice he had met Leonardo, who had shown him a portrait of her "which is a close likeness, well executed and could not be better done", thus highlighting its excellent naturalness and resemblance. On 27 March 1501, however, Isabella wrote to her correspondent in Florence, the Carmelite Pietro da Novellara, asking him to plead on her behalf with Leonardo "so that he might send another sketch of the portrait he is going to paint of us", specifying that the one he had left with her in Mantua had been given away by her husband to an unknown visitor. This large drawing, with its outlines pricked ready to be copied (or transferred to the panel), is the only surviving evidence of Leonardo's relationship with the marchioness and must be the master-template, from which derived the lost autograph copy left to Isabella (and perhaps the second one she requested through Novellara). The artist combines the medal-like profile befitting the rank of a noblewoman with an all-enveloping rotation of the entire torso, already heralding the pose of the *Mona Lisa* [fig. 53]. The portrait was never translated into painting, despite the sitter's insistence, expressed in a letter she wrote to the artist on 13 May 1504.

3. *Polyhedron*, from the 1509 edition of *De divina proportione* by Luca Pacioli (Venice, published Paganino de' Paganini), pl. XXXVI: *Rhombicuboctahaedron*, woodcut printed from wooden matrix, 29.5 × 21 cm. Florence, Biblioteca Nazionale Centrale, Fondo Nencini, inv. 2.8.8.16.
Leonardo's scientific association with the Franciscan mathematician was established upon the latter's arrival at Milan in the autumn of 1496, where he had been summoned by Ludovico il Moro as a teacher of Euclidean geometry. Eager for his teaching, Leonardo dedicated himself under his guidance to a diligent study of the theorems examined in *Summa de arithmetica, geometria, proportioni et proportionalità* (Venice, 1494), acquired for 119 *soldi* according to a punctilious note of expenses (Codex Atlanticus, fol. 288r). Their collaboration culminated in 1497–8, when Leonardo executed for Pacioli the geometric-perspectival illustrations for the magnificent manuscript with dedication of *De divina proportione*, published on 9 February 1498 (Ms Ambr. S.P. 6, ex Cod F 170 Sup.). In the later printed edition also published by the friar, they represent the Platonic regular polyhedrons (and their derivations), each in two versions, solid and 'empty' or transparent (revealing their structure, as though in latticework).

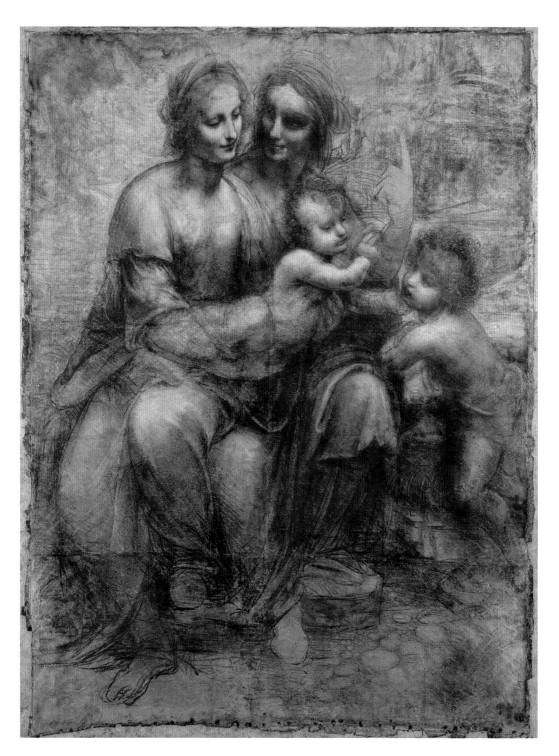

4. *St Anne, the Virgin and Child with St John the Baptist*, 1499–1501 or later (1502–5), charcoal, black chalk (or graphite?), *sfumino*, with white heightening on eight reddish prepared sheets (a mixture of iron oxide and calcium sulphate), mounted on canvas with animal glue, 141.5 × 104.6 cm. London, National Gallery, inv. NG.6337.
The cartoon seen by Pietro da Novellara on 3 April 1503 in Leonardo's studio in Florence at Santissima Annunziata, now lost, included a small lamb, "an animal for sacrifice that signifies the Passion".

The one mentioned by Vasari as being sensationally displayed to the public in the convent itself ("for two days it attracted to the room where it was exhibited a crowd of men and women, young and old, who flocked there, as if they were attending a great festivity") had a "St John, who is depicted as a little boy playing with a lamb". The biographer partly confused the iconography with that represented in the present cartoon, perhaps requested from Leonardo by the king of France, Louis XII, towards the end of 1499 (in honour of his wife Anne of Brittany and the birth of their daughter Claude in October) but its execution,

then interrupted, must have continued at least until 1501–2: in fact, it echoes the monumental and lively gestuality of the apostles in the *Last Supper* (completed in 1498) as well as the vestiges of the classical art seen by Leonardo in Rome and at Tivoli on 10 March 1501 (Codex Atlanticus, fol. 618v), in particular the sculptural group of the *Muses* dating from the time of Hadrian now in the Prado Museum in Madrid. The cartoon shows no traces of 'pricking' and was never prepared to be transferred for painting. Restored by Allan Brahan and Eric Harding in 1987.

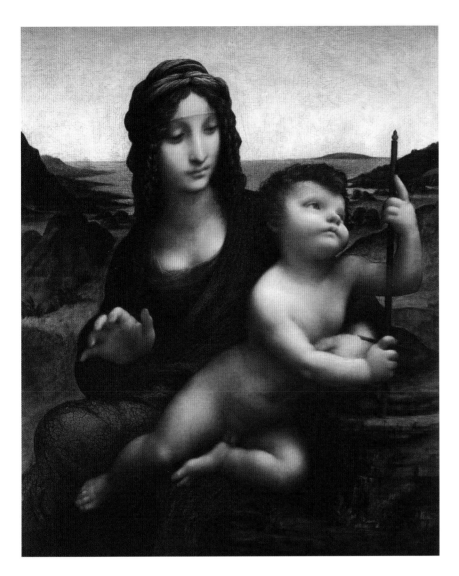

5. Leonardo (?) and assistant, *Madonna of the Yarnwinder*, c. 1501–6, oil on walnut panel (single board), 48.9 × 36.8 cm. Drumlanrig Castle, Collection of the Duke of Buccleuch and Queensberry (since 2008 on loan to the National Gallery of Scotland, Edinburgh, inv. NGL. 002.08).
Diligently noted by Pietro da Novellara, correspondent of Isabella d'Este, in a letter written to her on 14 April 1501 regarding the presence in Leonardo's studio in Santissima Annunziata of a "quadretino" intended for Florimond Robertet (secretary of state to Louis XII), it was described as "a Madonna seated as if she were about to spin yarn", alluding also to the symbolic element of the reel, a weaving tool inadvertently transformed by Jesus into the form of a cross, a portent of his future Passion. The present version – the only one, together with another in an American private collection, for which the direct involvement of the master can be claimed (perhaps in the skilful rendering of the geological stratifications of the stone seat in the foreground) – must correspond to the statement by the Carmelite friar himself (in an earlier letter of 3 April) in which he claims "two of his assistants made copies [*retrati*] and he [Leonardo] was involved in the making of some of them" (in which the word 'retrati' must have been used in its broadest sense to mean copies or derivations), clearly confirming the sporadic nature of the master's involvement in the work of his pupils.

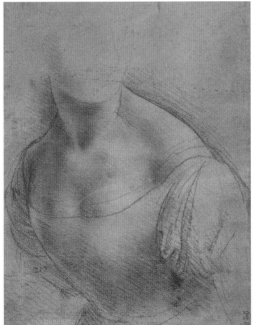

6. *Study for the Madonna of the Yarnwinder*, c. 1499–1501, metalpoint (lead?) and red chalk on red prepared paper, 22.1 × 15.9 cm. Windsor, Royal Library, inv. 12514.
Erroneously believed in the past to be a preparatory drawing for the portrait of Cecilia Gallerani, this lively female bust in a bold twisting pose has subsequently been correctly identified as an initial idea for the *Madonna of the Yarnwinder*. Executed sometime between 1499–1501, Leonardo resorts to a technique with notable atmospheric and chromatic effects, adopted for the first time in the more advanced studies of heads and hands for the apostles in the *Last Supper*: working on an initial outline in metalpoint, the artist has then modified the lines and shading using a chalk of the same colour red as the preparation of the paper support.

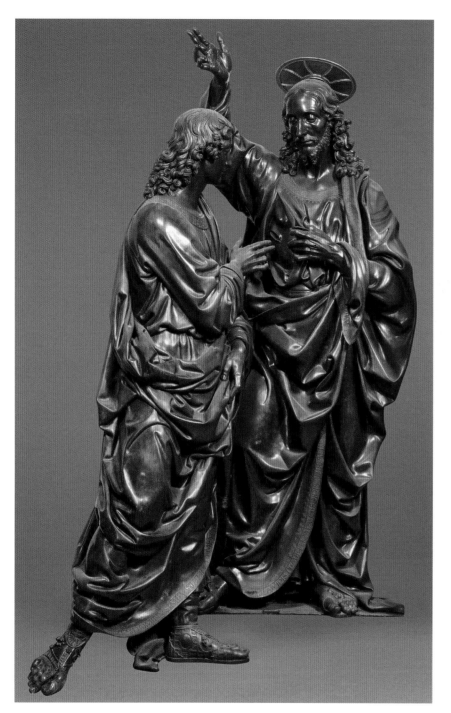

7. Andrea del Verrocchio, *Incredulity of St Thomas*, 1466–83, bronze, h. 241 cm (Christ) and h. 203 cm (St Thomas). Florence, Church and Museum of Orsanmichele.

This sculptural group was commissioned by the Tribunale della Mercanzia for the Tabernacle of the Arte della Mercanzia in Orsanmichele (central niche of the external eastern wall), created earlier by Donatello and his workshop between 1422 and 1425 in the form of an architectural aedicule: the subject chosen refers directly to the institutional role of the organisation, namely that of judging disputes between the various corporations. Executed in high relief, the back is hollowed out, and for this reason is now displayed in the museum in a structure imitating its original setting. Made using the lost wax technique: each of the two statues corresponds to a single casting, chased with chiselling when cold. Mentioned in an initial payment on 15 January 1466, the work was not placed in Orsanmichele until 21 June 1483, according to Luca Landucci's *Florentine Diary*. Its significance in Leonardo's stylistic development has been universally acknowledged, and is evident in the echoes of the sophisticated articulation of the gestures, poses and expressions in the composition of the *Last Supper*. Restored by the Opificio delle Pietre Dure in 1992.

8. Andrea del Verrocchio and Leonardo (?), *Madonna with Child and two Angels*, c. 1470–3, tempera and oil on poplar panel (single board joined to narrow lateral laths), 96.5 × 70,5 cm. London, National Gallery, inv. NG 296.

The attribution of this majestic composition (which belonged until 1857 to the Sensi Contugi family in Volterra), unanimously associated with Verrocchio's workshop and circle, is still the subject of discussion by experts. While the names of Pietro Perugino and Lorenzo di Credi have been proposed, under the master's direct supervision, in recent years reference to Verrocchio has gained the upper hand. Also proposed many times, the presence of Leonardo's hand might find confirmation in the evocative atmospheric rendering of sections of the landscape seen in the distance just above the head of the angel on the right: punctuated by lively bushes indicated by marks produced with the tip of a 'fan' brush and dominated by a rocky outcrop onto which the vegetation clings, close up it recalls similar characteristics in Leonardo's first drawing, the landscape dated 5 August 1473 [fig. 36]. Restored by Jill Dunkerton in 2008.

An impressive sculptor [7] and occasionally painter [8], his master was often in demand for works in metal and engineering, such as the gigantic copper sphere which in 1471 was placed on the summit of the lantern of the dome of Santa Maria del Fiore, and which Leonardo, by then an old man, would still recall around 1515 (Ms G, fol. 84v). In addition, Verrocchio was often called upon to produce ephemeral devices for celebrations and tournaments: an example can be found in the drawing for a standard for Giuliano de' Medici's joust of 1475 (now in the Uffizi), showing evident signs of the collaboration of his emergent apprentice [9].

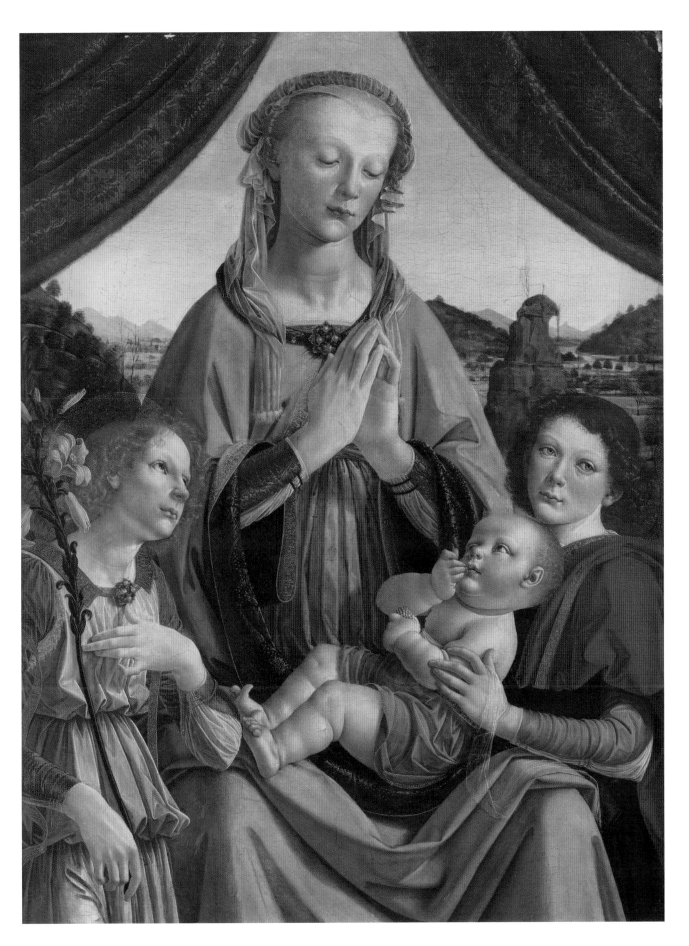

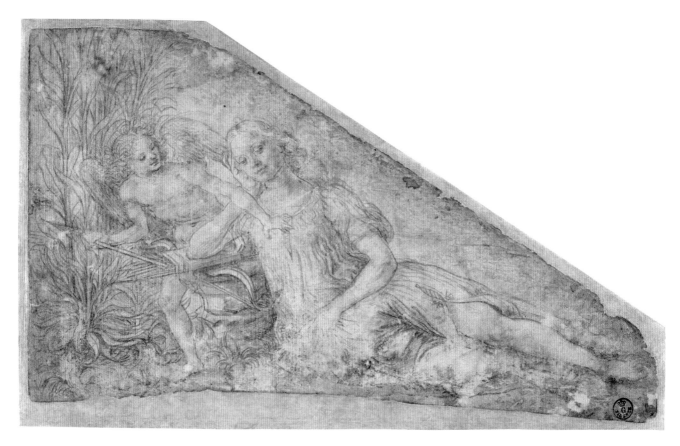

9. Andrea del Verrocchio and Leonardo (?),
Cupid and Diana the Huntress, c. **1475,**
silverpoint (?), charcoal and brown ink on ivory
prepared paper, 14.8 × 25.9 cm.
Florence, Gabinetto Disegni e Stampe
degli Uffizi, inv. 212 E.
The "painting of standard with a *spiritello* for
Giuilano's joust" is listed in the posthumous
inventory of Verrocchio's possessions, which

passed to his brother after his death (1488):
the reference is to the celebrated joust on
horseback, staged on 29 January 1475 by Giuliano
de' Medici in honour of his beloved, Simonetta
Vespucci. The triangular shape of the present
drawing confirms that it is a preparatory drawing
for the standard and the distilling of two different
techniques into its execution suggests that the
young Leonardo was responsible for the lively

finishing in black chalk which reworks the pre-
existing line by his master, executed in silverpoint:
the hand of the talented apprentice is particularly
evident on the left, where the agile winged figure
bursts forth from a bush of corn stalks, to remove
an arrow from the quiver of the sleeping maiden,
thus identifiable as Diana (or a nymph devoted to
her) rather than Venus, as commonly believed.

10. Andrea del Verrocchio, *Female head,*
c. **1475, black chalk (or charcoal) on unprepared**
paper, 32.5 cm × 27.2 cm. London, British
Museum, Department of Prints and Drawings,
inv. 1895.0915.785 verso.
The same (or a similar) face is repeated on
the back of the sheet, underlining, with more
accentuated effects of chiaroscuro (emphasized
by the highlighting in white and by lines in ink),
the complexity and sophistication of the hairstyle,
in line with the aristocratic models favoured by
Verrocchio. The present sketch, however, is aimed
instead at defining with lively strokes the features
and half-asleep expression: the faintly hinted detail
of the right hand on which the leaning head is
resting has enabled a link to be established with
the female figure in the triangular drawing for a
jousting standard of 1475.

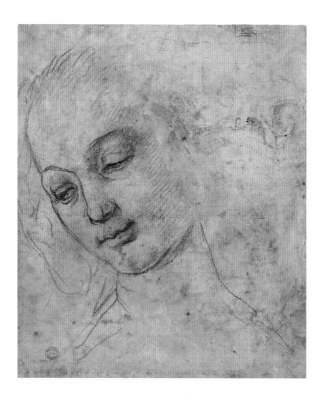

11. *Head of a Woman, c.* 1475–8, metalpoint (silver?), pen, brush and ink in two different shades with white heightening, on ivory prepared paper, 28.1 × 19.9 cm. Florence, Gabinetto Disegni e Stampe degli Uffizi, inv. 428 E.
Marking the pinnacle of the young Leonardo's production of drawings and suggested on several occasions as being one of the ideal heads listed in the inventory of works drawn up when he left Florence or established himself in Milan, around 1482 (Codex Atlanticus, fol. 888r): "head of a woman with knotted plaits", "head in profile with beautiful hair", "head with elaborate hairstyle". The formal sophistication displayed here corresponds to Vasari's words regarding the "female heads, beautiful in appearance and with beautiful hairstyles, which on account of their beauty Leonardo took as models". Attempts have been made in vain to associate this magnificent drawing with the Virgin in the small *Annunciation* in the Louvre (inv. M.I. 598), the authorship of which is still much debated between Leonardo and his fellow pupil Lorenzo di Credi: while related to this face of considerable size in the same emotional delicacy evoked by the pose in *profil perdu*, the little painted figure is also far removed from it in its summary and rapid translation into paint.

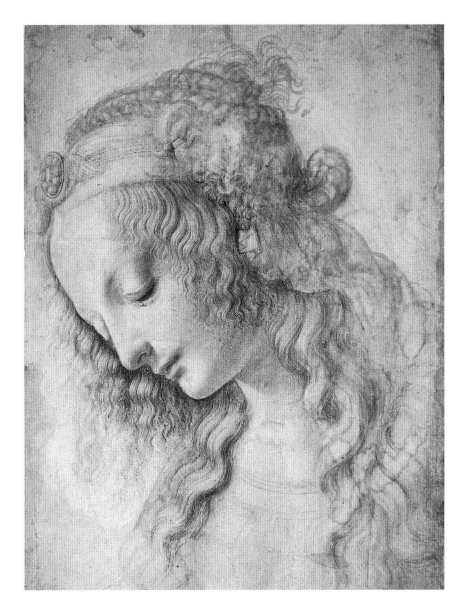

Trained in the rigorous exercise of drawing from his master's favourite models [10], the young Leonardo produced, with the same dedication, both aristocratic female heads with sophisticated hairstyles *all'antica* [11], whose chaste elegance resurfaces in the blonde, youthful Madonnas self-possessed in their dutiful reserve [12–13], and skilful monochrome studies of draperies of linen cloth [14], subsequently 'inhabited' by the quivering yet adamantine figures of angel and of the Virgin in the *Annunciation* [15]. He also produced spectacular and illusionistic three-dimensional projections of complex geometrical masses (the so-called 'mazzocchi'), from which one of his later sheets of studies from *c.* 1490 takes its inspiration, turning it however into a dazzling abstract and dynamic form [16], proudly signed as "body born of the perspective of Leonardo da Vinci, disciple of experience" (Codex Atlanticus, fol. 520r). That apprenticeship in the school of the truth of experience, whose origins lay in his youthful association with Verrocchio, would eventually enable him to master the observation and reproduction of reality to such an extent as to succeed in conceiving realistically even inventions that were purely imaginary.

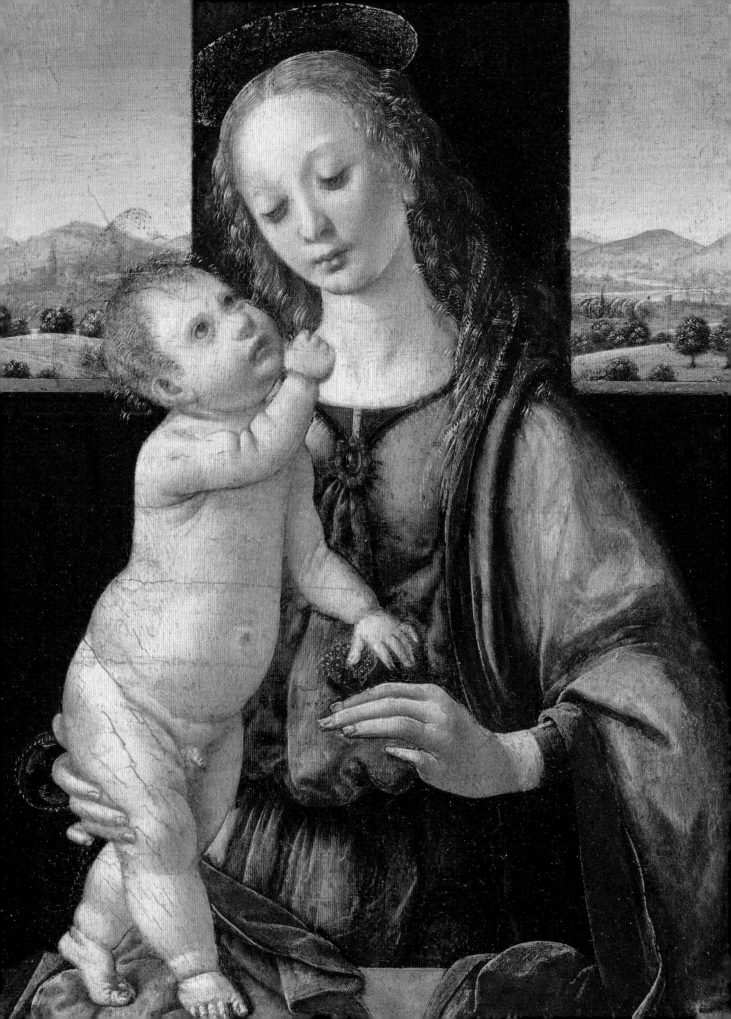

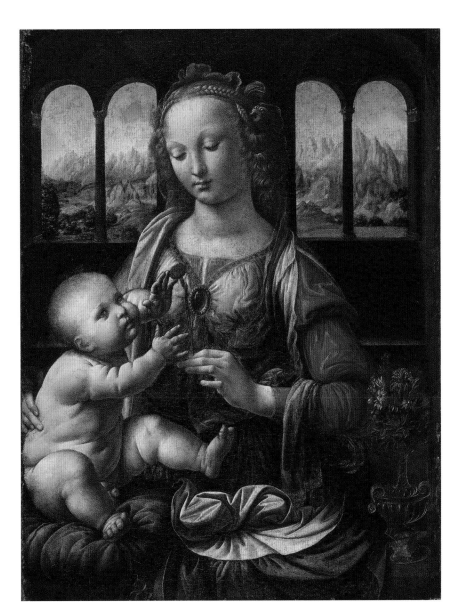

12. *Madonna of the Pomegranate (Dreyfus Madonna)*, *c.* 1469–70, oil on poplar panel (single board), 16.5 × 13.4 cm. **Washington, D.C., National Gallery of Art, Samuel H. Kress Collection, inv. 1952.5.65.** Known only since 1864, it was acquired in 1872 by the Parisian collector Gustave Dreyfus, whose heirs sold it to the New Yorker Joseph Duveen in 1930; its subsequent owner Samuel Kress donated it to its present location in 1951. It is the subject of perhaps one of the most controversial and fascinating attributional debates, involving the principal protagonists of Verrocchio's workshop: the authorship of this charming little panel (the size of a miniature) in fact oscillates between the master himself and his two principal pupils, Leonardo and Lorenzo di Credi. The hypothesis that it might be an example of a youthful work by Leonardo (perhaps even his earliest surviving painting) has, however, met with increasing consensus in recent years, culminating in its display at the exhibition held in 2015 at Palazzo Reale in Milan. The delicacy of the passages in chiaroscuro, which caress the Virgin's face through transparent veils, the sensitive reflections of light that strike the golden hair and above all the distant rendering of two stretches of landscape, in which the summits of the mountains almost evaporate as though heralding 'aerial perspective', are strong factors in favour of its attribution to Leonardo.

13. *Madonna with Child (Madonna of the Carnation)*, *c.* 1473–5, oil on poplar panel (two joined boards), 62.3 × 48.5 cm. **Munich, Alte Pinakothek, inv. 7779.** Lacking any verifiable basis, it has been speculated that this work might be identified with the *Madonna of the Carafe* that Vasari states as having been during his time in the possession of Pope Clement VII in Rome. In fact, nothing is known of the provenance of this work, prior to its mysterious appearance in 1889 in the private collection of Dr Albert Haug, who acquired it from the Wetzler family of Günzburg. The setting in the sumptuous interior of a noble residence, characterised by the lancet windows reminiscent of those executed by Michelozzo for the Palazzo Medici Riccardi, in addition to a possible allusion to the symbol of the Medici 'balls', in the crystal spheres of the pendant in the foreground that decorates the cushion on which Jesus is resting, have given rise to the cautious hypothesis of Medici patronage. Although inspired by Verrocchian models, this *Madonna* is distinguished by an extremely personal interpretation of the Child's liveliness, through the skilful treatment of the enlivened masses of the drapery and the almost surreal and metaphysical appearance of the landscape in the background.

14. *Study of drapery for a seated figure,*
c. 1475–80, traces of pen and ink, grey tempera
wash with white heightening, on grey prepared
canvas, 26.6 × 23.3 cm. Paris, Musée du Louvre,
Département des Arts graphiques, inv. 2255.
According to Vasari, from a very early age
Leonardo distinguished himself "sometimes in
making models of figures in clay, over which he
would lay soft pieces of cloth dipped in clay, and
then set himself patiently to draw them on a
certain kind of very fine Rheims cloth, or prepared
linen: and he executed them in black and white
with the point of his brush, so that it was a
marvel". The particular nature of this practice
originated in his apprenticeship in Verrocchio's
workshop and finds echoes in similar examples
produced by other prominent members of the
same circles, such as Domenico Ghirlandaio and
Lorenzo di Credi. The exceptional quality of the
present drawing has meant that, compared to
others, its status as an autograph work has
never seriously been doubted, due also to the
fact that it may represent an initial idea for the
drapery of the Virgin in the Uffizi *Annunciation*
(although it differs in the articulation of the folds
and the way they fall).

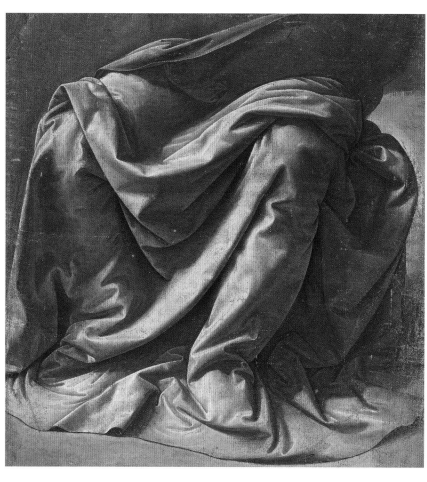

15. *Annunciation*, detail [see the whole picture in
the following pages] *c.* 1472–4, tempera and oil
on poplar panel (five boards joined horizontally),
98 × 217 cm. Florence, Gallerie degli Uffizi,
Galleria delle Statue e delle Pitture, inv. 1890
no. 1618.

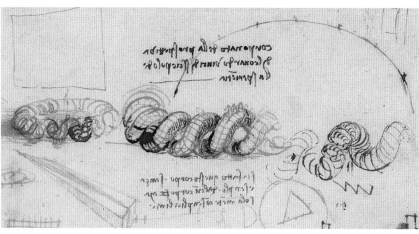

16. *Perspectival studies, c.* 1490, pen and ink
in two different shades on unprepared paper,
20.5 × 28.4 cm (whole sheet). Milan, Biblioteca
Ambrosiana, Codex Atlanticus, fol. 520 recto.
"This body should be made only with simple lines,
without following any existing model", in the adjacent
note, Leonardo commented thus upon the amazing
eruption of geometric and perspectival studies on
this sheet of what he proudly described as "body
born of the perspective of Leonardo da Vinci, disciple
of experience". Starting from the inspiration offered
by the rigorous drawing exercise of the three-
dimensional rendering of complex multi-faceted
objects (the 'mazzocchi', inspired by the famous
Florentine hats of the same name), which he had
been taught in his youth in Verrocchio's workshop,
a now mature Leonardo developed its exemplary
fixity into an astonishing and overwhelming coiled
dynamism, transformed visually into a form of pure
conceptual abstraction, an invention generated
by his mind as the result of his highly personal
'perspective'.

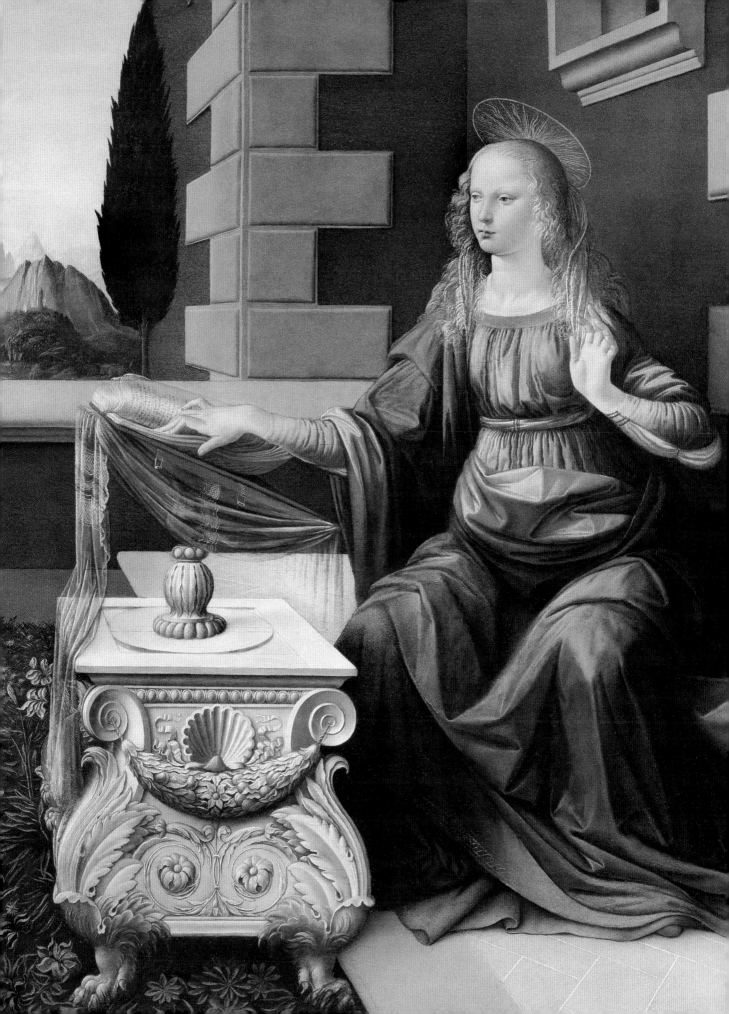

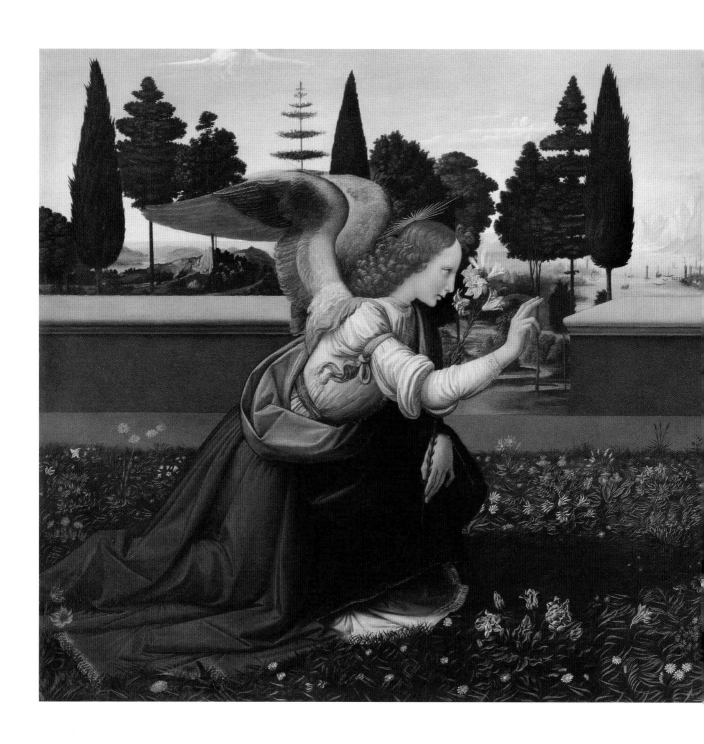

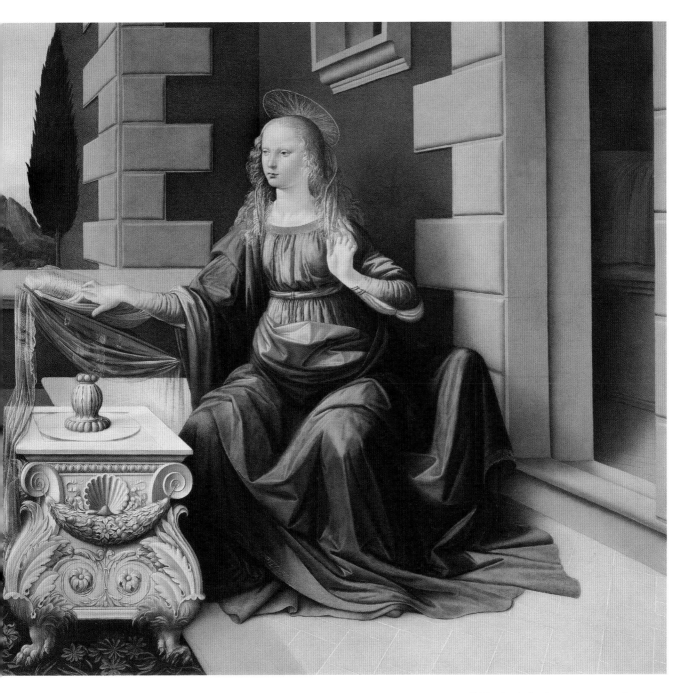

Annunciation, **c. 1472–4, tempera and oil on poplar panel (five boards joined horizontally), 98 × 217 cm. Florence, Gallerie degli Uffizi, Galleria delle Statue e delle Pitture, inv. 1890 no. 1618.**

Formerly in the monastery of San Bartolomeo a Monte Oliveto, it is not known whether this was its intended destination: in fact, there is no mention of the painting until the 19th century, when it was thought to be the work of Ghirlandaio. The attribution, now widely accepted, to the young Leonardo, under the influence of Verrocchio (with the ornate sculptural pedestal of the Virgin's lectern paying evident homage to his Medici tomb in the Old Sacristy in San Lorenzo), rests on eloquent details (such as the dynamic movement of the drapery, the hydromorphic cascade of the angel's curls, the naturalism of the vitality of the flowering meadow and of the row of trees silhouetted against the light, right up to the distant view of a mountain landscape rendered transparent by atmospheric filters). These are, however, reconstituted in the complexity of a perspectival, almost anamorphic construction that suggests an oblique view, in accordance with a foreshortened viewpoint on the right, perhaps confirming that it was originally placed along the side wall of a chapel. Restored by Alfio Del Serra in 2000.

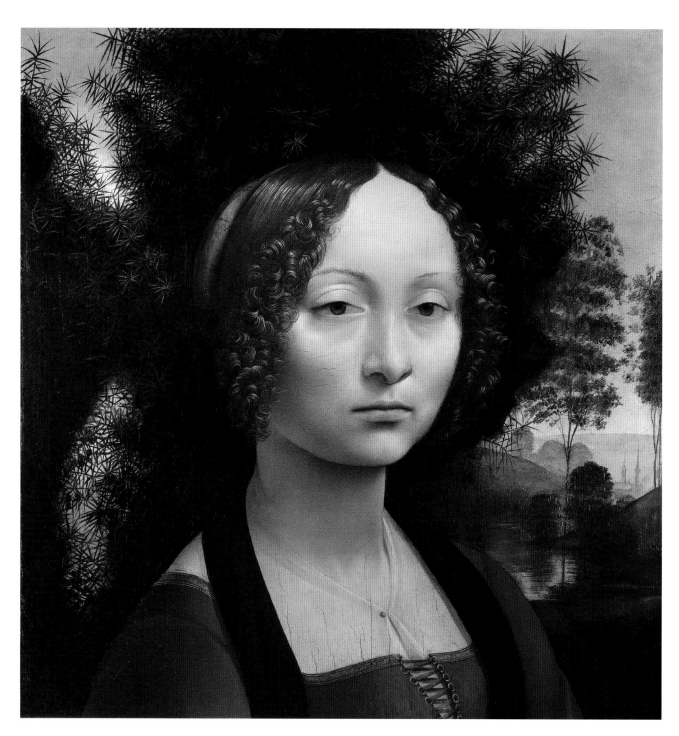

17. *Portrait of Ginevra Benci, c.* 1474–5,
tempera and oil on poplar panel (single board),
38.1 × 37 cm (cut below by about 12–15 cm).
Washington, D.C., National Gallery of Art,
Ailsa Mellon Bruce Fund, inv. 1967.6.1a.
The young woman, admired and celebrated for her
virtue in verses by Lorenzo the Magnificent and
other contemporary poets and platonically loved
by the Venetian ambassador Bernardo Bembo,
married Luigi di Bernardo di Lapo Niccolini in

1474 and it is commonly believed that Leonardo
portrayed her shortly afterwards. Identification is
based on the thick blanket of foliage that acts as
her crown, recognised as a juniper alluding both
to the name of the sitter and the incorruptibility
of her female virtue (as it is an evergreen): in
fact, a branch of the same plant also appears
on the back of the painting in the guise of a faux
porphyry, between two other symbolic wreaths
(laurel and palm, indicating intellectual and moral

values). Between them unfolds a cartouche with
the motto "Virtutem Forma Decorat" (beauty is
ornament to virtue). The melancholy that seems
to cloud the moon-like pallor of the face (animated
nevertheless by the vibrant reflections of the
sweeping curly hair) is ideally mirrored in the damp
rendering of the lacustrine landscape. Restored by
David Bull and Eric Gibson in 1991.

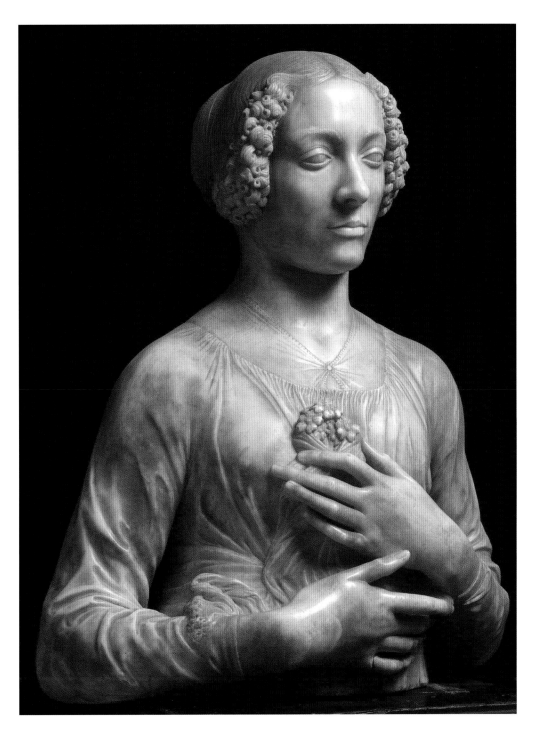

18. Andrea del Verrocchio, *Woman with a Bouquet*, 1475–80, marble, 59 × 46 × 24 cm. Florence, Museo Nazionale del Bargello, inv. Sculture no. 115. The revolutionary concept of this bust lies as much in the innovative presentation of the sitter's arms and hands as in the three-dimensional circularity of the composition: unlike other contemporary portraits sculpted in accordance with an obligatory frontal or side view, the figure is conceived to be seen in the round, from all viewpoints. Although it is widely acknowledged as a model for the portrait of *Ginevra Benci*, this work by Verrocchio was destined to leave a lasting impression on Leonardo, who was still to echo its sophisticated approach to space in the sculptural pose conferred on *La Belle Ferronnière* [fig. 47].

The vivid plasticism of Verrocchio's sculpture, capable of conferring organic verisimilitude on the forms represented, would establish itself in his aesthetic vision as a distinguishing feature of his own conception of the world. Leonardo's works in drawing and painting, moreover, reveal well known literal borrowings from it: we can take as an example the derivation of *Ginevra Benci* of 1474–5 from the almost contemporary *Lady with a Bou-quet*, although in comparison almost softened, albeit in its solid structure, by the dissolving of the lacustrine landscape and by the atmospheric shine of the silky hair, revealing an awareness of Flemish art [**17–18**]. Then there are palimpsest-works in which it is possible to distinguish their direct collaboration, marked by a precise division of parts: from *Tobias and the Angel* of *c.* 1469 to the *Baptism of Christ* of 1473–5 [**19–20**].

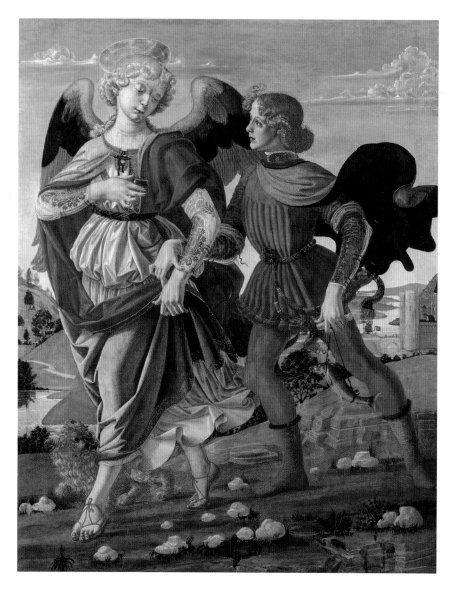

20. Andrea del Verrocchio and Leonardo, *Baptism of Christ*, c. 1470–3 and 1475–8, tempera and oil on poplar panel (six boards joined vertically), 179.5 × 152.5 cm. Florence, Gallerie degli Uffizi, Galleria delle Statue e delle Pitture, inv. 1890 no. 8358.

The presence in San Salvi, a church situated just outside Florence's city walls (now no longer in existence), of Verrocchio's brother Simone, who had been abbot of the monastery since 1468, has led to the assumption that the (undocumented) commission for this panel must have taken place around 1469–70. Its execution, however, in the unanimous opinion of scholars, continued throughout the next decade, covering the entire period of Leonardo's apprenticeship with Verrocchio. The attribution to his hand of the angel on the left seems to go back to Francesco Albertini's *Memoriale* (1510) and was then reiterated by Vasari (1550 and 1568), who considered it rhetorically as the debut of Leonardo's artistic career. In reality, it is now thought that his involvement (which also extends to the fluid landscape in the upper left and to an attempt to unify the remaining parts both technically and stylistically) reveals a level of maturity referable to the period between c. 1473 and 1475–8. Restored in 1998 by Alfio Del Serra.

19. Andrea del Verrocchio and Leonardo (?), *Tobias and the Angel, c. 1469–70*, tempera and oil (?) on poplar panel (single board), 83.6 × 66 cm. London, National Gallery, inv. NG 781.

The painting takes up an iconographic theme already executed in 1469 for the church of Orsanmichele by the Pollaiolo brothers with the much larger panel now conserved in the Galleria Sabauda in Turin and it is therefore plausible that it was produced by Verrocchio's workshop in direct competition but perhaps for a domestic altar, given its much smaller dimensions. The sculptural presence of the two protagonists, who remain as though frozen in their respective movements, despite the attempt to confer dynamism on the fluttering of the Archangel Raphael's robes and the swirling of Tobias' mantle as they walk, is mitigated by the inclusion, in the lower left, of the lively dog, who seems overpainted with light white strokes of the brush on the pre-existing layout of the conventional landscape background. Its attribution to the hand of the very young Leonardo is made likely by the incredible realism with which the animal is represented, in the act of turning its head and lifting its paw in a sign of lively curiosity.

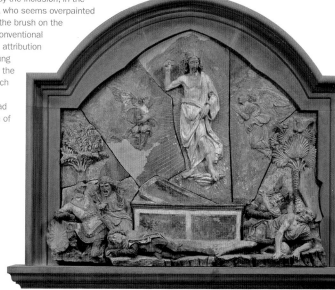

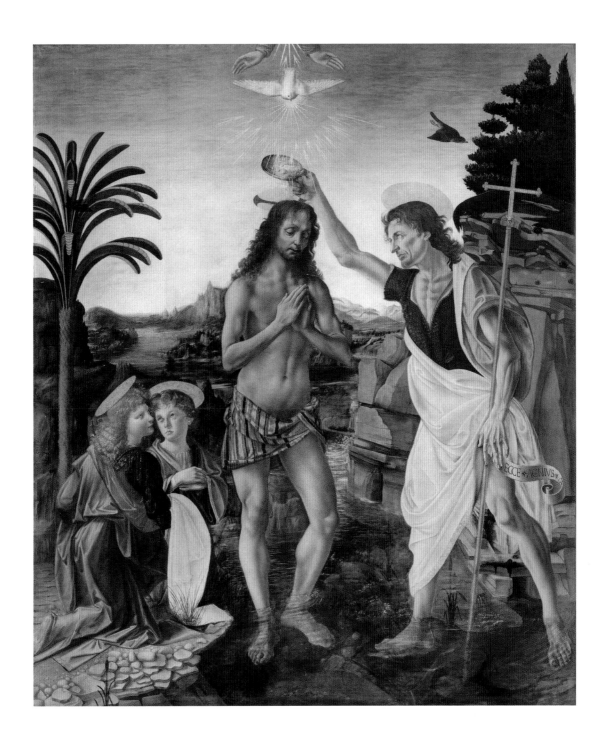

21. Andrea del Verrocchio, *Resurrection of Christ*, c. 1478, polychrome terracotta (fragmentary), 135 × 138 cm. Florence, Museo Nazionale del Bargello, inv. Sculture no. 472.
The work originates from the Villa Medici at Careggi, where it was rediscovered in an attic only at the end of the 19th century by its owner at the time, Carlo Segré. He had the nine surviving pieces of the work reassembled and then placed in the central courtyard, where it remained until 1930, when it was acquired by the Italian State and transferred to its present location; it is probable, however, that it was originally situated above the door of the chapel in Cosimo the Elder's villa. The model Verrocchio followed is undoubtedly the lunette executed between 1442 and 1445 by Luca della Robbia for the north door of the sacristy of the Duomo in Florence. However, in place of the solemnity of the latter, a remarkable atmosphere of exaggerated pathos is evident, combined with a lively and expressive dynamism. Works like this well illustrate the atmosphere of "agonistic physiology" in which, according to Roberto Longhi (1952), "Leonardo's difficulties" would originate and increase.

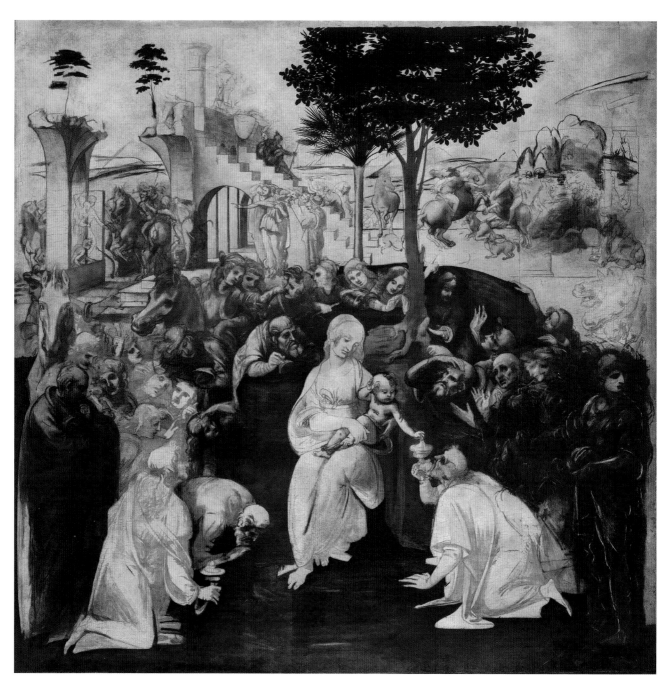

22. *Adoration of the Magi*, 1481, unfinished (gesso ground, preliminary drawing in charcoal and brush drawing with diluted lamp black, water colour in blue, indigo and red vegetable dye, white lead primer, wash in tempera and brownish-yellow bistre, white lead highlighting) on poplar panel (ten boards joined vertically), 243 × 246 cm. Florence, Gallerie degli Uffizi, Galleria delle Statue e delle Pitture, inv. 1890 no. 1594.
As notary for the monastery of San Donato a Scopeto from 1479, ser Piero da Vinci was able to promote the commission of this altarpiece from the Augustinian canons to his son's advantage, according to a contract stipulated in March 1481, and thanks to a donation made to the monastery by Simone di Antonio di Piero. While it has been speculated that the unusual clause debiting to the artist the expenses incurred in acquiring materials (including pigments) might explain the decision to leave the panel sketched out almost entirely in monochrome, recent restoration by the Opificio delle Pietre Dure (2013–17), freeing it from the layers of transparent varnish applied for conservation purposes and which later oxidised, has revealed that the technique of unfinished painting should be seen as a deliberate choice by Leonardo, who must evidently have realised that he could not bring to fulfilment the tumultuous ferment of his compositional ideas, a 'drawing while painting' that now presents us with this remarkable testimony of a work in progress. Left at the Benci residence in 1482, it is documented as being in the Casino Mediceo in Via Larga from 1621; it then passed to the Uffizi in 1670 from where it was temporarily moved on a single occasion, returning there definitively in 1794.

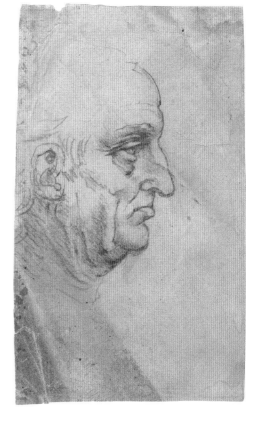

23. *Project for a hydraulic device,* c. 1510, red chalk on unprepared paper, 12.9 × 7.8 cm. Milan, Gabinetto dei disegni di Brera, inv. 7415 verso. This small sheet, first published only in 1988 after its fortuitous acquisition on the art market for only a few thousand lire, arrived in its present location thanks to Lamberto Vitali's bequest. What is now designated as its verso shows a summary sketch for a device that is repeated in an almost identical way in a more detailed drawing on fol. 95r of Ms G in the Institut de France: on the basis of this similarity, it is possible to ascribe to it the date of c. 1510 accepted for the manuscript, and to hypothesize that the present sheet also came directly from it, as the dimensions are also compatible. The hydraulic device represented is a water meter that Leonardo had made by a craftsman from Domodossola for the orator Bernardo Rucellai, according to the reliable testimony of Benvenuto della Volpaia in a codex in the Biblioteca Marciana in Venice datable to c. 1510.

24. *Man shown half-length in profile facing right,* c. 1510, red chalk on unprepared paper, 12.9 × 7.8 cm. Milan, Gabinetto dei disegni di Brera, inv. 7415 recto. Bernardo Rucellai (1448–1514) was the brother-in-law of Lorenzo the Magnificent, having married his sister Nannina de' Medici in 1466. Son of the learned humanist Giovanni, friend and correspondent of Marsilio Ficino, Bernardo served Florence several times in a valuable diplomatic role, continuing after Lorenzo's death in 1492 and the Medici's expulsion from the city (1494). His first legation in the Sforza court, begun between the end of 1481 and the beginning of 1482 and lasted until 1484, concerned the war of Ferrara: it has consequently been suggested that he might have accompanied Leonardo on his journey to Milan and he certainly acted as mentor and reference for him from the moment of his arrival. It has also been suggested that the elegant humanist hand of the letter of presentation to Ludovico il Moro, which is not Leonardo's, might be his. The male profile drawn here, on the other side of a sheet that shows a sketch of a device designed for him, might therefore show him in his later years, at the age of around 62.

The modern and dramatic figures sculpted by Andrea [21] affirm a *pathos* which powerfully resurfaces in the symphony of pulsating masses modulated by the swirl of the bystanders in the magnificent *Adoration of the Magi* for the Augustinian monks of San Donato a Scopeto [22]. Commissioned in 1481 but left unfinished the following year when he departed for Milan, the *Adoration* is a seminal work, returned to its original state by the recent restoration by the Opificio delle Pietre Dure: Leonardo displays, together with a meditated reflection on Donatellian models and Albertian precepts on the theme of 'history painting', an advanced knowledge of classical statuary.

His first independent commission, dating to 10 January 1478, was for an altarpiece for the chapel of San Bernardo in the Palazzo Vecchio, which was never executed. Shortly before, between 1476 and 1478, he must have frequented the garden of San Marco, where Lorenzo the Magnificent kept the prestigious family collections of classical sculptures, making them accessible to the artists of the time (including Verrocchio himself): in fact, many years later (towards 1508), Leonardo would recall this place as the "Medici orchard" in connection with a classical subject, the

"Labours of Hercules" (Codex Atlanticus, fol. 783v). One of his early biographers, the so-called Anonimo Gaddiano, stated in c. 1540 that Lorenzo "in exchange for a stipend made him work in his service in the garden of Piazza di San Marcho [sic]" (thus alluding to an association corroborated by the payment of a salary); the information paves the way for the role the Magnificent subsequently played in Leonardo's departure for Milan to enter the service of Ludovico Il Moro.

The move to Lombardy, in fact, probably occurred within the context of a shrewd interweaving of diplomatic relationships in which the orator Bernardo Rucellai, Lorenzo's brother-in-law and a contemporary of Leonardo, was also involved, having been despatched that same year 1482 as ambassador to the Sforza court in the aftermath of the war of Ferrara. A long-lasting friendship most probably developed between the artist and the ambassador, as testified by a sheet of studies of 1508–10, which shows on one side a sketch of a hydraulic device [23] documented earlier as a water meter made for Rucellai, whose portrait might well be identified in the profile of the elderly man on the other side of the paper [24].

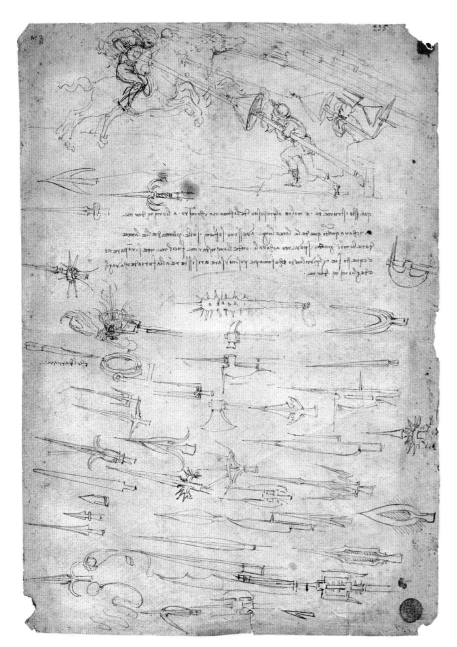

25. *Studies of weapons and combatants*, *c.* 1484, metalpoint, pen and ink on unprepared paper, 29.3 × 20.8 cm. Venice, Gallerie dell'Accademia, inv. 235 recto.

In his *Treatise* (Milan 1584), Giovan Paolo Lomazzo states that Leonardo produced for Gentile de' Borri, a well-known man-at-arms at the Sforza court who ran a fencing school in the so-called 'Osteria della Balla', a book on the military arts, now considered lost. It has nevertheless been suggested, on the basis of some perforations along the left margin (presumably made in view of it being sewn to other similar sheets), that the present sheet might constitute one of the surviving pages of this 'book', which should probably be considered as an album or notebook of sketches with relative accompanying notes. The numerous blades and heads for lances and halberds illustrated in the lower part of the sheet are studied with the aim of "frightening the horses enormously, so that the order of the cavalry might easily be disrupted: this is the most useful method the foot soldiers can use to resist the fury of the horses and riders": the note, above which is a drawing of the encounter between two riders on horseback and two foot soldiers, clarifies that the complex shapes of these weapons are imagined with the strategic purpose of allowing the foot soldiers to instil fear into the horses.

Leonardo brought with him to Milan the draft of a letter of presentation to Ludovico Sforza (Codex Atlanticus, fol. 1082r), perhaps written (or dictated) by Rucellai himself, in which he alerted his future patron to his range of skills in the field of engineering and military architecture [25–6], but which also promised him "the bronze horse may be taken in hand, which shall endue with immortal glory and eternal honour the happy memory of the Lord your father and of the illustrious house of Sforza". This referred to the equestrian monument to Francesco Sforza long desired by Ludovico [27], but a feat tragically destined to remain incomplete as, at the end of 1494, the bronze required for its casting was redirected to Milan's ally Ferrara so that it could be used instead for cannons to avert the threat posed by the French. Yet, between 1491 and 1493, Leonardo had already prepared, with an innovative conceptual design, the form enclosed as though in a metal corset in the mold for casting [28].

26. *Study for war machine (siege trebuchet),* *c.* 1485, metalpoint, pen and ink on unprepared paper, 29.3 × 20.8 cm. Venice, Gallerie dell'Accademia, inv. 235 verso.

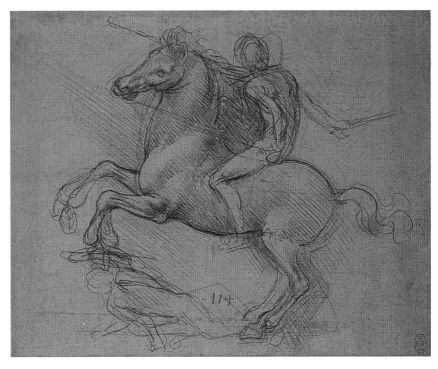

27. Study for the first design for the equestrian monument to Francesco Sforza, *c.* 1489–90, metalpoint on blue prepared paper, 14.8 × 18.5 cm. Windsor, Royal Library, inv. 12358.
Sheet fol. 15v of Ms C bears the annotation (dated 23 April 1490) "I recommenced the horse", indicating that the ambitious undertaking of the equestrian monument to Francesco Sforza had earlier been temporarily suspended, as also

confirmed by a letter on 22 July 1489 from Piero Alamanni, the Florentine ambassador in Milan, to Lorenzo the Magnificent, conveying Ludovico's request to procure "one or two masters, suited to such a work", revealing mistrust as far as Leonardo was concerned. On the basis of stylistic and technical affinities with contemporary anatomical studies, the present drawing must date to a period between 1489 and the above-mentioned annotation: in June 1490, while

visiting Pavia with Francesco di Giorgio Martini, Leonardo was highly impressed by the late Antique equestrian statue known as *Regisole* (Sun King; Codex Atlanticus, fol. 399r), deciding to adopt the same solution of the horse's ambling gait, rather than the bold rearing position, on hind legs and in the act of trampling the enemy, testified by this drawing, but difficult to execute.

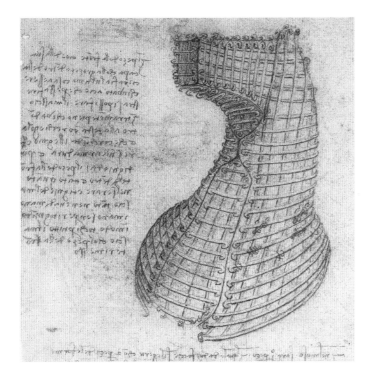

28. Study for equestrian monument to Francesco Sforza (mould for casting the horse's head and neck), *c.* 1491–3, red chalk on unprepared paper, 22 × 30 cm (whole sheet). Madrid, Biblioteca Nacional de España, Ms 8936 (Madrid Codex II), fol. 157 recto.
The compilation of the manuscript can be assigned to the period between 1491 and 1493: bearing the date 20 December 1493, and separated by only a few pages (fol. 151v), is Leonardo's confident assertion: "I have decided to cast the horse without the tail and on its side". On the basis of the annotations and drawings contained in this manuscript and in some contemporary sheets in the Codex Atlanticus, it appears that the innovative casting technique invented by Leonardo for the execution in bronze of this monumental horse (three times larger than lifesize and for which the terracotta model is estimated to have weighed about sixty tons) envisaged that a hollow mould would be filled with wax and then with a layer of fireproof clay. When the wax melted, the resulting vacuum between the mould and the layer of clay would be filled with molten bronze, in a single casting and with no need to use subsequent joints.

In the letter to il Moro, his assertion of his ability also "to do in painting whatever can be done, as well as any other, be he who may" (revealing the proud desire to measure himself against any painter on the Milanese scene), was then put into practice, beginning with the altarpiece for the chapel of the Immaculate Conception for the destroyed church of San Francesco Grande, commissioned (in collaboration with two local artists, the brothers Evangelista and Giovan Ambrogio de Predis) on 25 April 1483. Leonardo produced an initial version, now known as the *Virgin of the Rocks* [29], which sets an unprecedented silent, perturbing dialogue between radiant spiritual presences in the shadowy vortex of a damp geological womb. It was, however, never delivered to the patrons and was instead, perhaps at Ludovico's request, destined for the marriage dowry of his niece Bianca Maria, bride of Emperor Maximilian I, reaching Innsbruck in 1493.

With the resulting plea from the Franciscan brothers to Ludovico to intervene on their behalf and a parallel offer to Leonardo from a private admirer (perhaps the King of France who wished to 'steal' the painting from the brothers by making a higher offer), a lengthy dispute began, resolved only twenty five years later following a legal argument on 27 April 1506 (at the time of Leonardo's return to Milan, by then in French hands). The result of this dispute was the painting's substitution with a second version of the *Virgin of the Rocks*, partly rectified in its iconography [30]: already begun in 1491–3, executed with secondary assistance from the workshop but left unfinished in some parts in 1506–8, and the only one actually to be placed for a certain time on the Confraternity's altar. It differs from the first version of the subject in a more cerebral distribution of the lighting based on colder and more enamelled hues, in a more sculptural and tactile definition of the volumes and in the daring acceleration of the perspective in the background, where the gaping chasm opens onto the mountainous landscape cut between the rocks.

29. *Virgin of the Rocks* (first version),
c. 1483–6, oil on panel, transferred to canvas,
199 × 122 cm. Paris, Musée du Louvre, inv. 777.
If it arrived in Innsbruck as part of Bianca Maria Sforza's marriage dowry in late 1493, the painting may subsequently have come to Fontainebleau (where it was recorded by Cassiano dal Pozzo in 1625) through the marriage of Eleanor of Austria, daughter of Emperor Maximilian I, to the French king François I in 1530. This is the first version of the altarpiece for the Confraternity of the Immaculate Conception, destined since 1483 for the church of San Francesco Grande, but over which a legal dispute had already arisen between the brothers and the artists involved by 1493, despite the payment of almost the entire fee attested by a document dated 23 December 1484 (or 1489). The disagreement had perhaps originated in the problematic iconography (only partly rectified in the version that replaced it, now in London), which, thanks to the gaze and gesture of the angel Uriel focusing attention on the infant St John the Baptist, appears to reflect the semi-heretical theological opinions of Amedeo Mendes da Silva regarding the role played by the Baptist in the revelation of the dogma of the virginity of Mary.

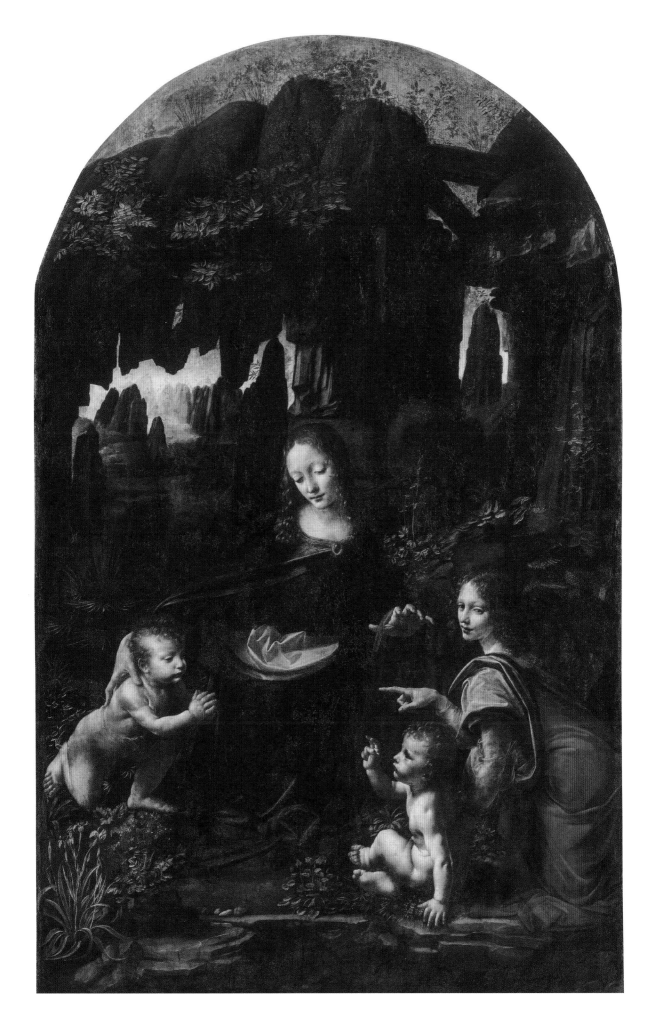

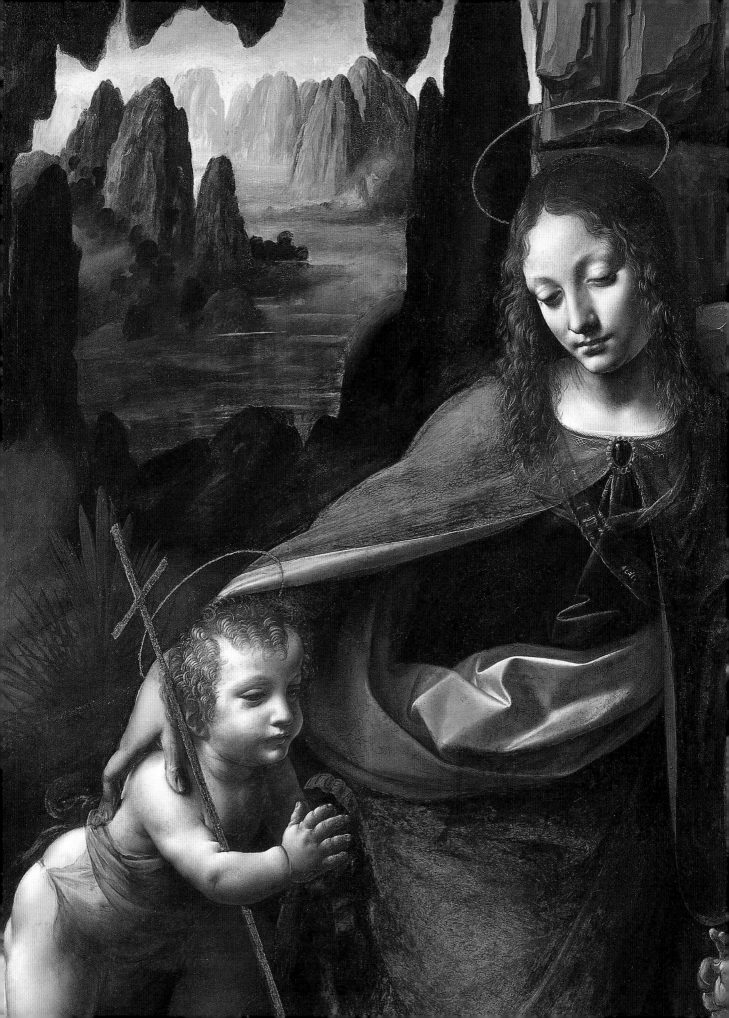

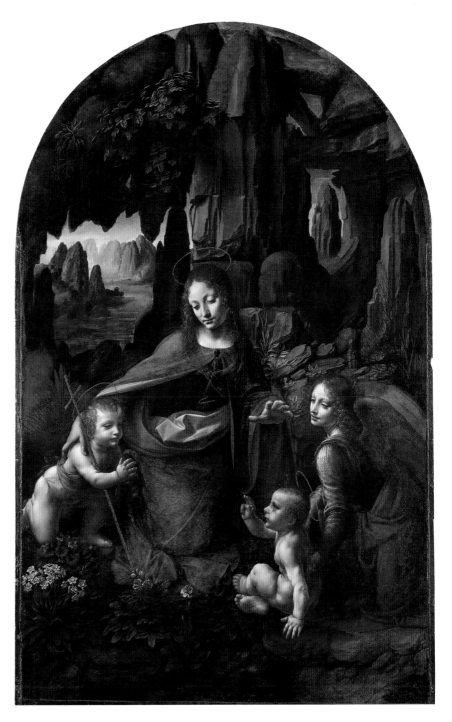

30. Leonardo (and workshop?), *Virgin of the Rocks* **(second version),** *c.* **1491–3 and later (resuming work in 1506–8), oil on poplar panel (five boards joined vertically and parqueted), 189.5 × 120 cm. London, National Gallery, inv. NG 1093.**

Comparison with the matching copy commissioned by Cardinal Federico Borromeo to the painter Vespino between 1611 and 1614 and now in the Pinacoteca Ambrosiana, suggests that the haloes and Baptist's cross should be considered 17th- or 18th-century additions, unrelated to the painting's original composition. The placement of the work on the altar of the Immaculate Conception in San Francesco Grande, replacing the first version, can be inferred from a document dated 27 April 1506: it remained in Milan once the Confraternity was dissolved (1781) and until its acquisition by the collector Gavin Hamilton (1785), who took it to England. Despite the negative opinions expressed in the past by critics, accustomed to viewing the work as executed almost entirely by Giovanni Ambrogio de Predis, analyses carried out during a recent restoration by Larry Keith (2008–10) have revealed that a substantial part is by Leonardo's hand (in the skill that can be seen, for example, in the refined figure of the angel), with only partial and marginal assistance from his workshop in the secondary areas of the rocks and vegetation.

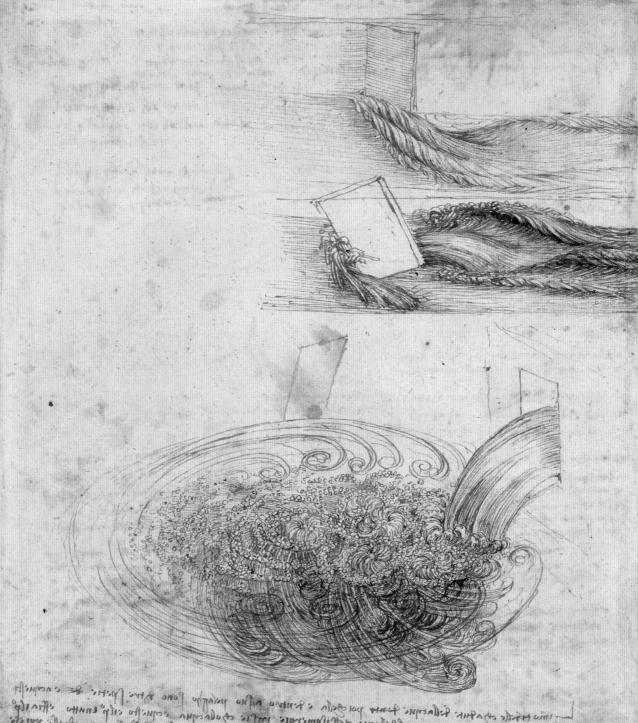

As if the world "breathed"

Leonardo's affirmation started in Milan, not only from an artistic point of view, but also an entirely intellectual one, confirmed by his strong desire to entrust to the febrile compilation of notebooks full of writings and observations the gradual expanding of his interests. An annotation jotted on a Milanese manuscript of *c.* 1492 exemplifies the fundamental and emblematic analogy he established metaphorically (albeit on the basis of genuine empirical observation), according to which the circles produced by a stone thrown into a pond were ideally comparable to waves of sound resonating through the air:

> Just as the stone thrown into the water becomes the centre and the cause of various circles, the sound made in the air spreads out in circles.
> (Paris, Institut de France, Ms A, fol. 9v)

A few years later, around 1494, this analogy was multiplied and amplified in a magnificent piece of writing, in which the spreading of waves of water and sound is in its turn compared to the greater reverberations produced by fire in space (for example, through the sudden gash in the heavens caused by thunder and lightning), and the still more vast projection of the waves of the mind in the infinite dimension of the universe. This extract reminds us how also the emotional vocal tremors of the apostles in the contemporary *Last Supper* at the announcement by the tragic figure of Christ (caught in the deep suffering of his own humanity) of the imminent betrayal, responds to the same 'law' that associates the unravelling of the 'mental states' of the guests with a sonic or acoustic impulse. Christ's painful announcement, in fact, is reflected in the form of emotional waves manifest in the orchestration of the various reactions in terms of gestures and

expressions [32], as also summarily indicated in the preparatory sketch for the first idea for the mural painting [33]. Leonardo thus writes:

> Water struck by water forms circles around the point that has been struck. The same thing in a wide space happens to the voice in the air and in an even larger space when fire spreads through the air; and for an even larger space still the mind when it spreads in the universe, although, since the mind is finite, it cannot stretch to infinity.
> (Paris, Institut de France, Ms H, fol. 67r)

The text, significantly entitled "De anima", in alluding to the vitality of the 'body' of the earth as natural macrocosm (in a twin correspondence with the human microcosm), begins with a heuristic introduction: "The movement of the earth against the earth, being of the same matter causes a small movement in the part struck" (as though alluding to the essential immobility of the earth as a whole, while wishing to take into account its internal telluric changes). The passage thus reveals itself to be a semantic amalgam of physics of the elements (earth, water, air, fire) and is evocative, *in nuce*, of Leonardo's universal conception of nature, which acknowledged decisive and reciprocal connections and analogies between man and the natural world considered in its entirety. This world was conceived as a single, gigantic living organism: *natura naturans*, represented as such, for example, in the astonishing and illusionistic wall cross-section of roots and rocks in the so-called Sala delle Asse – originally the 'Camera de' Moroni' – in the Castello Sforzesco. Here, in fact, Leonardo's portentous imagination immerses the spectator in the very labyrinths of the substratum pulsating with life [34].

31. *Studies of whirlpools, c.* 1508–10, traces of black chalk, pen and ink on unprepared paper, 29 × 20.2 cm. Windsor, Royal Library, inv. 12660 verso.

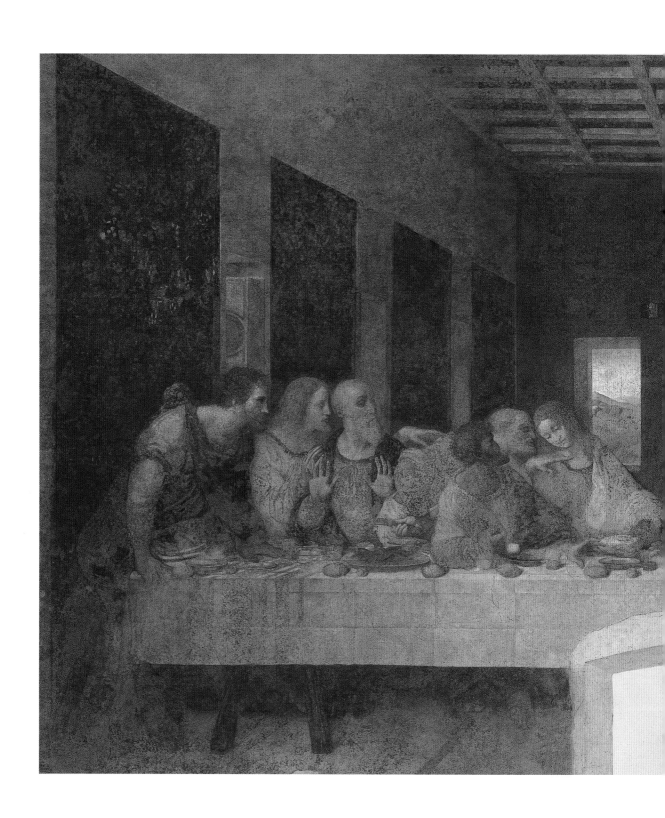

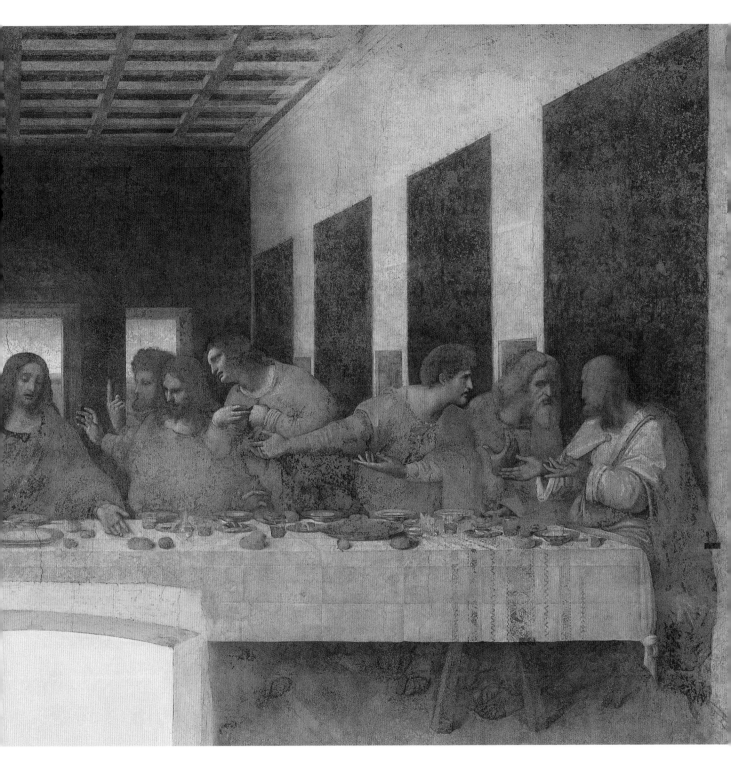

32. *Last Supper*, *c.* 1494–8, tempera and oil on two layers of gesso ground (calcium carbonate and lead white), applied to plaster, with gold finish residue, 460 × 880 cm. Milan, Santa Maria delle Grazie, refectory (north wall). The precise date of the official commission by Ludovico il Moro is unknown, but (although not directly documented) it can be deduced from a letter written to his secretary Marchesino Stanga, dated 29 June 1497, requesting him to urge "maestro Leonardo the Florentine to finish the work begun in the Refectory of the Grazie". The extreme slowness in execution was undoubtedly due to the entirely experimental nature of the technique used to paint directly onto the large wall with tempera and oil paints, as though it were an extremely large painting on panel: the pigments were applied *a secco*, rather than adopting the fresco technique which would, on the contrary, have called for very rapid execution, and not been congenial to the continuous reconsiderations typical of Leonardo's practice. The configuration of the architectural setting in which the scene takes place, conceived on the basis of a spectacular and scenographic perspectival structure with illusionistic intent, is aimed at extending the actual architecture of the refectory into the painted room. Restored by Pinin Brambilla Barcilon between 1977 and 1999.

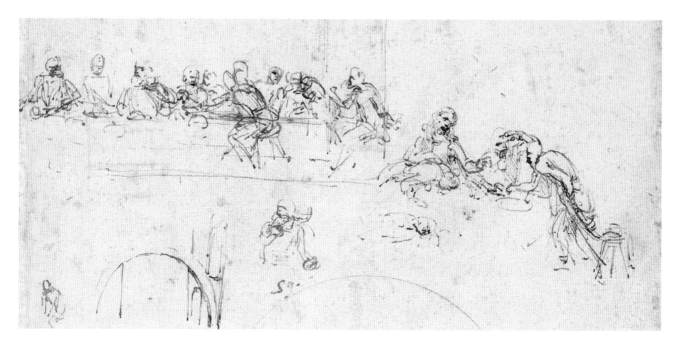

33. *Preparatory sketch for the 'Last Supper'*, c. 1490–2, pen and ink on unprepared paper, 26 × 21 cm (whole sheet). Windsor, Royal Library, inv. 12542 recto.
The studies of architecture and geometrical proportions occupying the middle and lower part of the sheet (apparently executed first), have, on the basis of their affinities with drawings related to the lantern tower of the Duomo in Milan (on which Leonardo was working between 1487 and 1490; fig. 38), enabled the preparatory sketch for the *Last Supper* to be backdated to a period between 1490 and 1492–4. Almost contemporary is the date of the annotation on fol. 1041r of the Codex Atlanticus, in which a direct link between the spreading of concentric ripples on the surface of water and the spreading through the air of a sonic or vocal reverberation is established (as in Christ's announcement of the betrayal): "just as the stone, when it hits the surface of the water, becomes the centre and cause of various circles, which spread until they disappear, so the air struck by the human voice or by a sound, spreading in circles, gradually disappears; so that whoever is closest (to the origin of the sound) hears more clearly, and whoever is further away hears almost nothing".

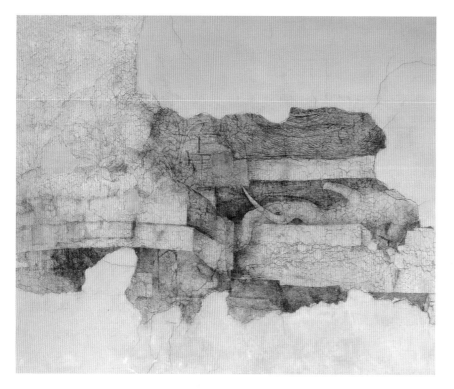

34. *Geological cross-section of roots and rocks*, so-called *Monochrome*, c. 1498–9, unfinished (incised lines, drawing in charcoal and pigments – red and yellow ochres – brushed on with organic binding agent), on plaster, c. 820 × 300 cm (irregular outline, c. 536 × 191 cm maximum width for the largest fragment only). Milan, Castello Sforzesco, north-east tower, Sala delle Asse.
In a letter written on 21 April 1498 to Ludovico il Moro, the duke's chancellor Gualtiero da Bascapé informed him: "On Monday the large Sala delle Asse, in the tower, will be dismantled. Maestro Leonardo promises to finish it by September" (that is to say that the previous wooden furnishings were to be dismantled to make space for the new decoration by Leonardo, who, on his part, undertook to complete the work by the following autumn). A subtle restoration under the supervision of Michela Palazzo (since 2013) and still in progress has brought to light new fragments of 'sinopie' representing branches, foliage and a schematic hamlet. Leonardo specifically intended to represent mulberry trees, 'mori', as they allude not only to the nickname of Ludovico, but also to the Duchy's economy, based on the farming of silk worms through the cultivation of mulberry trees.

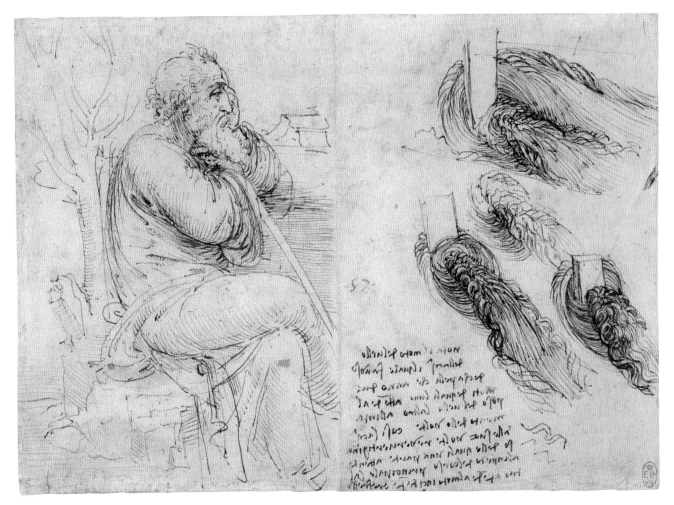

35. *Figure of an old man in contemplation in a landscape (a self-portrait?) and studies and notes on the movement of water, c. 1506–8 or later (1510?), pen and ink on unprepared paper, 15.3 × 21.3 cm. Windsor, Royal Library, inv. 12579.*
This remarkable sheet, the dating of which varies in the opinion of scholars between 1506–8 and 1510 (at a moment nevertheless almost contemporary with the compilation of the bifolia of the Codex Leicester, largely devoted to studies of hydrodynamics), has recently been the subject of a distinguished essay by Pietro C. Marani (2018) which, highlighting its direct link with the drawings and notes on both sides of the sheet in the Royal Collection at Windsor, inv. RL 12660 [fig. 31], has also reiterated the significance for the fundamental morphological analogy, established by Leonardo both in drawing and writing, between "the movement of the surface of water" and the way in which hair describes "two movements, one of which follows the weight of the hair, the other the line of its waves". Thus, the "vertiginous vaults" intrinsic to water, namely its dizzying whirlpools (the result of the "impetus of the principal flow" as well as the "accidental and reflected movement", caused that is to say by obstacles placed in its way) seem directly comparable to the sinuous flow of the hair drawn or painted by Leonardo, for example in the *Baptist* in the Louvre [fig. 57], also datable by *c.* 1509.

Passing unexpectedly from a physical to a metaphysical level, Leonardo resorts – with an intuition both lyrical and scientific at the same time – to the image of the stone thrown into water to illustrate, still in line with Ptolemaic-centred medieval cosmology, the movement of change and mutation from one state to another, carried out by natural elements as though it were a transit across their respective 'spheres'. The result is the vision, of astonishing beauty, of the 'circles' – or spreading of concentric rings – produced as though by successive reverberations of the mind in the contemplation of the boundless space of the universe, exactly as waves spread indefinitely on the surface of water from the point of impact. The analogy is thus submitted to a dizzying acceleration, which immediately spreads from one concept to the next, with a rapidity of which even Leonardo is forced to acknowledge the limit; finite, the human mind is confronted with the impossibility of emulating the infinite mutability of the natural universe.

It is water as *vitale omore* – a life-giving humour – which runs through the body of the earth, ramifying it with invigorating veins, that is followed in the iridescent morphology of its dynamism [35]. The element thus becomes the visible vehicle of cosmic metamorphosis, assuming a formidable demonstrative quality, of which Leonardo had been aware since he was young: the mobile fluidity that already distinguishes the water in the earliest of his surviving drawings, dated 5 August 1473 [36], provides initial evidence of this.

The theoretical basis of this belief, *The Beginning of the Treatise on Water* outlined in the same manuscript of 1492, from which

the passage of writing that constituted our starting point is taken, opens with a pronouncement from the fascinating pre-Socratic and neo-Platonic legacy: "Man was called by the ancients 'the world in miniature'". The statement is then immediately explained in an elaborate analogy, organicist in tone (that is to say aimed at establishing an exemplary equalisation between the physics of the elements and the physiology of the body):

> inasmuch as man is composed of earth, water, air and fire, his body resembles that of the earth; and as man has in him bones the supports and framework of his flesh, the world its rocks the supports of the earth; as man has in him a pool of blood in which the lungs rise and fall in breathing, so the body of the earth has its ocean tide which likewise rises and falls every six hours, as if the world breathed; as in that pool of blood veins have their origin, which ramify all over the human body, so likewise the ocean sea fills the body of the earth with infinite veins of water.
>
> (Paris, Institut de France, Ms A, fol. 55v)

The "infinite veins of water" which ramify across this "body of the earth", the Ocean which "rises and falls as if the world breathed", the rocks that are the "supports of the earth" like a "framework of flesh": these reflections were formulated at the height of the almost two decades Leonardo spent at the Sforza court in Milan (c. 1482–99). The same correspondence between micro- and macrocosm had, nevertheless, already appeared in an evocative allegorical guise in a text dating the to the last years of his earlier formation in Florence, on the fringes of the circles of Lorenzo the Magnificent and Ficino, around 1478–80.

The theme of the consumption of matter carried out by the inexorable passage of time, taken from Pythagoras' discourse in Book XV of Ovid's *Metamorphoses* (a work dear to Leonardo since his youth, and which he knew through the popularising 14th-century manuscript by the notary Arrigo Simintendi) presents the "likeness of the moth that flies at the flame": tragically imitating the suicidal flight of the moth towards the flame that inexorably attracts it, man yearns for the inexorable succession of the seasons without realising that by doing so "he desires his own decay", because inherent in him is "the hope of returning to his origins and of returning to the primal chaos" (almost a premonition of the reunion of man with the primal totality of the life of the universe). Leonardo recognised in this impetus "that quintessential spirit of each element, which finding itself confined as a soul in a body, desires to return to where it came from". Thus, the intellectual mind is regarded as a *quintessence*, namely a fifth element added to the four of Aristotelian physics: "imprisoned" in the materiality of the body, it nevertheless yearns

spasmodically for an eternal return to where it came from, that is to say the same primal cosmic entity from which it originated. Man's very existence, therefore, was interpreted by Leonardo as the vital reverberation of the universal breath of the world (its "breathing") instilled in his physical body, thus making him part of cosmic life and of the solemn and tragic rhythm of its alternation, marked by the pulsation of its breath: "man is the model of the world" (Codex Arundel, fol. 156v).

The focal exemplarity of man in Leonardo's naturalistic and cosmological conception, therefore, acts and manifests itself in accordance with two biunivocally correlated directions: on one hand, as an entity forming part of the universe, he is a "world in miniature" that originated from it, repeating on a smaller scale its structure and functions; on the other, his body presents itself as "the model of the world", that is to say almost as the modular tool for the interpretation and comprehension of nature. This is a clearly anthropocentric concept, admirably illustrated by the celebrated *Vitruvian Man* [37], the ideal image of *homo bene figuratus* conceived by the Roman architect Vitruvius in his *De architectura*. The drawing is based on the canon of the perfect proportions of a human body simultaneously inscribed in the two fundamental geometric paradigms (the circle and the square, in their turn astral symbols of the cosmos and the earth), which also govern the construction of every building, a concept that Leonardo was similarly able to learn from Alberti's *De re aedificatoria*. So even an architectural construction could be conceived and structured as an organism resembling the human body, in the way explained by Leonardo in a letter addressed to the *fabbricieri* of Milan cathedral, around 1487–9, with his proposals for a project for the lantern tower of the dome. It was in fact on this occasion that Leonardo explicitly compared a metaphorical analogy of the "ailing duomo" requiring the attention of "a doctor-architect" with the beneficial relationship that should exist between a person who is ailing and the one who cures him (Codex Atlanticus, fol. 730r). In fact, his drawing of the sagittal section of the cupola (ibid., fol. 850r; [38]) is consequently conceived in accordance with a keen sense of the 'physiology' of its structure, making intelligible its supporting 'framework'; similarly, some almost contemporary projects for fortified buildings [39] show the application of this same innovative 'exploded' view – resolved in imaginary sections, virtually opened to show through dissection the internal articulation – used in the anatomical studies begun around 1489 for a planned book "on the human figure" [40].

In his later years, however, this anthropocentric paradigm would inevitably break down, overturning into its exact opposite. The confident reliance on the ability of *homo faber* to make himself protagonist, inventor and 'measure' of his own destiny in the world would make way for a pessimistic view, which literally

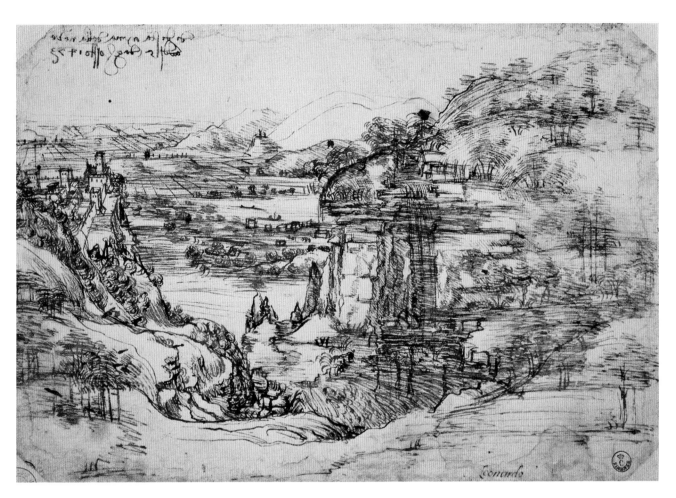

36. *Study of landscape (Valdarno, between Monsummano and the marshes of Fucecchio?),* dated 5 August 1473, pen and ink in two different shades on unprepared paper, 19.6 × 28.7 cm. Florence, Gabinetto Disegni e Stampe degli Uffizi, inv. 8 P recto.

The uniqueness of this well-known drawing lies in the dated annotation in the top left ("feast of St Mary of the Snow – day of August 5th, 1473"), which makes it the earliest surviving document of Leonardo's artistic career, as well as of his writing. The protagonist in 1977 of a memorable essay by Giulio Carlo Argan, and continuing to exert a fascination even now – more than for the exact topographical location of the view represented, itself the subject of endless discussion – is the creative energy in the spontaneous rendering of the view of the naturalistic scene, supported by the precocious skill in the free and impulsive use of the pen and ink technique, achieving results that are almost impressionistic, such as the rendering of the bushes in the form of shifting fans of light or the fall of the water from the rocky spur on the right, by which infinite "circles around the place struck" are generated in the basin below.

37. The proportions of the human body in the manner of Vitruvius (Vitruvian man), c. 1490, stylus, metalpoint (lead?), pen and ink, with touches of watercolour on unprepared paper, 34.4 × 24.5 cm. Venice, Gallerie dell'Accademia, inv. 228.
Undoubtedly Leonardo's most celebrated drawing, regarded as the very symbol of western civilisation and of the ideal anthropocentrism inspired by Renaissance humanism. Recently interpreted as the possible preparatory study for an illustrated plate (or perhaps the frontispiece) of a planned book *De statua*, which, following the example of the short treatise of the same name by Leon Battista Alberti (but lacking any iconographic content), Leonardo was planning to write around 1490–2 (according to a note on fol. 43r of Ms A), the drawing is his personal interpretation (an alternative compared to those of his contemporaries, such as his friend and colleague Francesco di Giorgio Martini) of the canon of the perfect proportions of a *Homo ad circulum et quadraturm*, drawn up around 15 BC by Marcus Vitruvius Pollio, based on his *De architectura*. The uniqueness of the solution adopted by Leonardo lies in the simultaneous presentation of two perfectly superimposed images, with the possible transition and exchange of the position of the limbs from one figure to those of the other.

38. Study for the lantern tower of the Duomo in Milan, in sagittal section, c. 1487–90, traces of black pencil, pen and ink partly brushed onto unprepared paper, pricked for transfer, 33.2 × 29.3 cm. Milan, Biblioteca Ambrosiana, Codex Atlanticus, fol. 850 recto.

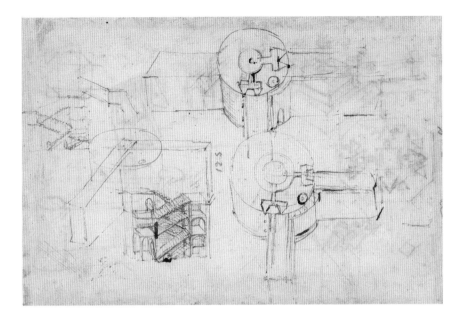

39. Study of towers *divided into sections*, c. 1485–90, pen and ink on unprepared paper, 13.6 × 20.4 cm. Milan, Biblioteca Ambrosiana, Codex Atlanticus, fol. 763 recto.

40. Study of sections of legs, c. 1485–90, metalpoint, pen and ink on unprepared paper, 22.2 × 29 cm. Windsor, Royal Library, inv. 12627 verso.

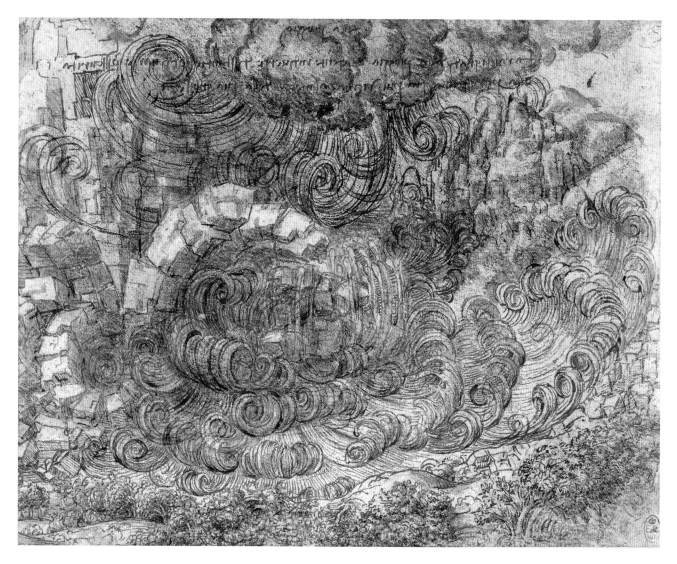

41. *Deluge, c.* **1517–18, black chalk, pen and ink in two different shades with brown watercolour, on unprepared paper, 16.2 × 20.3 cm. Windsor, Royal Library, inv. 12380.**
"On rain. You will show the degrees of falling rain in various distances and in varying degrees of obscurity; and the darker part will be that which is closer to the middle of its thickness". This is written in the autograph note, clearly pragmatic in nature, scribbled at the top of the sheet, emerging from the confused cluster of stormy clouds: Leonardo captures the intensity of the shower of rain both in the distance from which it is seen and in the degree of darkness in the visual perception. A *memorandum* most probably intended to be developed further in a corresponding chapter in the planned *Libro della Pittura*, later compiled as an apograph by Melzi. The drawing resorts to highly intellectualised drawing techniques to achieve what has been evocatively described by Martin Kemp (1982) as an "orgy of destructive violence". The extreme aesthetic stylisation adopted in the swirling currents of water, so that they almost resemble curls of hair (in keeping with a well-known analogy, recorded on the sheet in Windsor, RL 12579; fig. 35), increases the sublime and perturbing expressiveness of the image.

foresaw the disappearance of every human being, annihilated by the mighty roaring of the *Deluges*, the disasters and cataclysms that would destroy all vestiges of civilisation, through a sort of frenzied and punitive implosion of the natural elements themselves, earth, water, air and fire [**41**]. Leonardo arrived at this extreme vision irrespective of any biblical implication, echoing if anything classical *topoi* relating to natural phenomena such as storms and hurricanes (examples are to be found in authors he was familiar with, such as Ovid and Seneca).

In the course of his entire experience as investigator and experimenter, Leonardo oscillated between two contrasting sentiments concerning nature, "to some merciful and benign mother, to others most cruel and merciless stepmother" (Codex Atlanticus, fol. 393r). These two states of mind had already been revealed, in the same set of reflections arising from his reading of the *Metamorphoses*, in the form of two ambivalent reactions, "fear" and "desire". They were described in another passage of writing in which Leonardo imagined himself at the entrance of a mysterious lair (almost

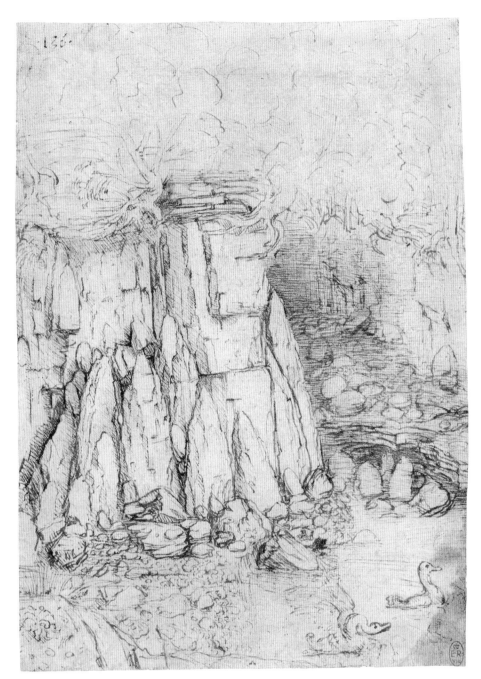

42. *A stream in a rocky gorge*, c. 1482–5, pen and ink on unprepared paper, 22 × 15.8 cm. Windsor, Royal Library, inv. 12395 recto.
Although it cannot be considered a preparatory study in the literal sense, in type the drawing recalls the rocky landscape of the first version of the *Virgin of the Rocks* [fig. 29]: in the opinion of experts, on the basis of technique and style it belongs to the years just after Leonardo's arrival in Milan (*c.* 1482), while from an iconographic point of view, the sharp and steep geological schists, with a proliferation at their summit of wild shrubs, correspond to a type of naturalistic scenery Lombard in origin, then often repeated in Leonardo's graphic repertoire. The gravel represented in transparency on the river bed still evokes the cobblestones in the foreground of the *Baptism* [fig. 20] and already heralds the lenticular clarity of that in *St Anne* [fig. 54], originally lapped by a pool of water.

the counterpart of the Platonic cave), which had become the symbol of man's bewilderment before the immensity and terror of the knowable world [42]: he expressed "fear towards the dark and threatening cave, and at the same time the desire to see if there was something wondrous there" (Codex Arundel, fol. 155r). Caught between attraction and consternation, these words express his tension regarding the natural world and it seems that in them also reverberates the echo of the Senecan concept of the earth's interior as casket or repository of wonders, as well as a place

of terror. The fleeting nature of "consuming time" and the voracity of "envious antiquity" which swallows traces of the past leaving almost no memory of them (Codex Atlanticus, fol. 195r), themes also taken from the fictitious discourse Pythagoras is made to pronounce by Ovid, reappear in another paradigmatic text from the ancient world on naturalism also known to Leonardo from his final years with the Medici: Pliny the Elder's *Historia Naturalis*.

The work is already mentioned, by 1489, in the list of barely five titles that appears, as the embryo of his future library and

43. *Sketches of 'caricature' and 'grotesque' heads, among various notes,* c. 1487–90, pen and ink in two different shades on unprepared paper, 20 × 14 cm. Milan, Archivio Storico Civico e Biblioteca Trivulziana, Libretto d'appunti (Codex Trivulzianus 2162), fol. 1 verso (p. 2).
On the facing page, beside the design for a ship complete with ladder for a 'sea tower' for military offensives, is inscribed a short list consisting of five titles: "Donato Lapidario Plinio Abacho Morgante" (namely: a canonic manual of Latin grammar; a medieval text on the classification of rocks; a version of *Storia Naturale* popularised by Cristoforo Landino in 1476; a book of calculus for use by merchants and craftsmen; Luigi Pulci's greatest poem). The seven caricature heads shown here are accompanied below by a witty and direct anti-Petrarchan triplet, indicative of Leonardo's aversion to the poet's epigons who populated the courts of the time: "If Petrarch was so fond of laurel – Laura – it's probably because the laurel leaf is a good condiment for sausages and roasted blackbirds. As far as I am concerned, I cannot abide such rubbish". Lower down, appears the sharp motto: *Salvatico è quel che si salva* ('Savage is he who saves himself', perhaps adopted by Leonardo polemically in allusion to his own self-taught knowledge, which must have appeared 'savage' to humanist scholars).

44. *Study of an old and a young man facing each other,* c. 1490–4, red chalk on unprepared paper, 20.9 × 15 cm. Florence, Gabinetto Disegni e Stampe degli Uffizi, inv. 423 E.
The juxtaposition of the two profiles with their characteristic complementary features derives from the Verrocchian invention of the two facing reliefs of Darius of Persia and Alexander the Great, recorded by Vasari as a diplomatic gift from Lorenzo the Magnificent to Matthias Corvinus, King of Hungary, and perhaps executed around 1480, in the light of the shared impending threat from the Turks. The originals in bronze, now lost, were frequently copied in the workshop, extending the exemplary comparison also to other leaders from antiquity, including Hannibal and Scipio Africanus. Drawings like this, dating to the middle of Leonardo's time at the Sforza court, were in their turn copied by followers and imitators of the artist (such as the painter from Lodi, Giovanni Agostino, already known as Pseudo Bramantino, who was instrumental in transmitting and making them known also in the Veneto) and they were even translated into sculpture by Tullio Lombardo and his circle.

early testimony of his interests as a bibliophile, subsequently cultivated at length, on the third page of the Codex Trivulzianus, beside, significantly, a set of seven caricatural heads, which offer a humorous example of the distortion of human features with the passage of time [43]. In Pliny's work, Leonardo could read of the legendary beauty of the masterpieces in painting and sculpture of the ancient world tragically lost (such as Praxiteles' *Venus* and that by Apelles, mentioned in Book XXXV), observing that the products of the intellect and art

are also subject to the fateful effects of time. A *memento mori* of universal significance and Petrarchan in its evocation ("mortal beauty passes and does not last"), is a verse taken around 1493 from a sonnet from the *Canzoniere* (Codex Forster III, fol. 72r), vividly fixed in edifying drawings such as the ones in which Leonardo contrasts the profiles of bald, toothless old men, consumed by age in their sagging and wrinkled flesh, with Apollo-like young men, with perfect features and exuberant, seductive curly hair [44].

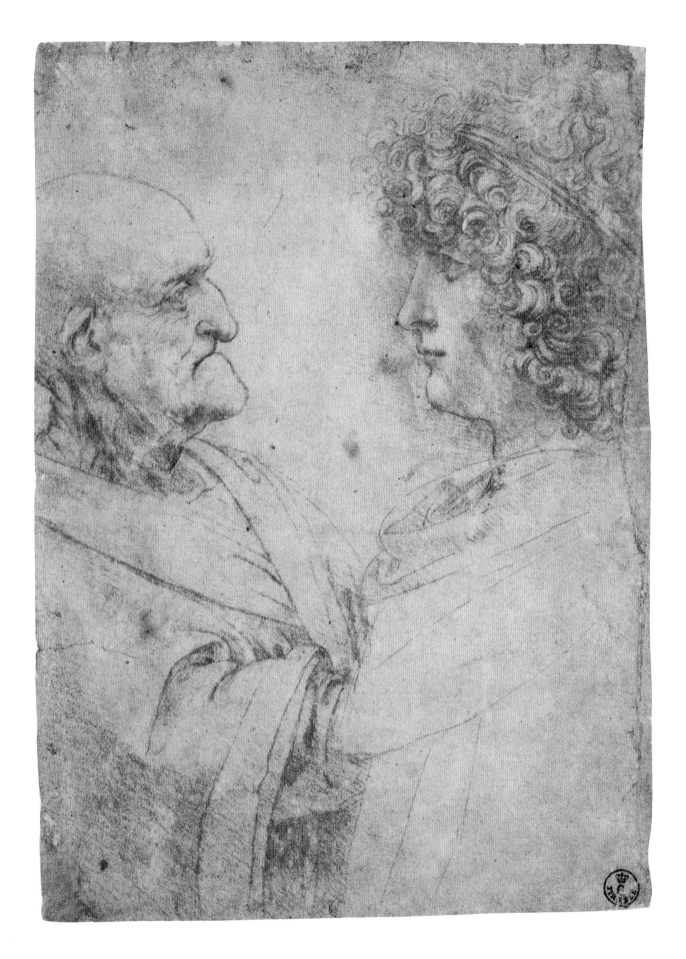

The eye in dreams

45. *Studies of the proportions of the face and eye, c.* 1489–90, metalpoint, pen and ink on unprepared paper (two reunited fragments), 14.4 × 11.6 cm and 19.7 × 16 cm. Turin, Biblioteca Reale, inv. 15576 and 15574.

A sublime imaginative connotation is thus conferred by Leonardo on the reflection and inquiry conducted from the beginning of his intellectual exploration of the natural world. As abundantly expressed in the posthumous transcript of the *Treatise on Painting*, compiled by his faithful pupil and heir Francesco Melzi from the autograph manuscripts to which he had direct access (now largely lost), the ability of the eye [45] to act as "the window of the soul, through which the soul mirrors and appreciates the beauties of the world" (*Treatise on Painting*, §28), enables the "ingenuity of the painter" to act "like the mirror which always assumes the colour of the thing it reflects" (ibid., §56). The eye is an intermediary, a 'window' of the soul receptive to the appreciation of the beauties of the world but also to reflecting it as though in a mirror, capable of absorbing its form and colours: the ability of the painter, among all other men, consists however in amplifying the phenomenon of reflection, making it – beyond a mere and mechanical act of specular duplication – a visionary 'transmutation', capable of generating a splitting of reality.

"The divinity of the science possessed by the painter means that his mind becomes a likeness of the divine mind" (ibid., §68): thus the 'science' of the painter proves worthy of *divinity*, because through it he can compare his own ingenuity with divine creation. In the assimilation of reality obtained through precise optical-sensorial cognitive exploration [46], the painter (who is also a natural philosopher and *artifex*) was, according to Leonardo, capable of introjecting natural forms, in order to then re-shape them in an exercise of creative invention from which to generate a 'second nature'; the painter was, therefore, a "feigner/inventor" (ibid., §177) and thus revealed the 'demiurgic' potential of his act. In a passage that has justly become famous and significantly entitled *How the painter is lord of every kind of person and of all things* (ibid., §13), Leonardo in fact clarifies that "whatever there is in the universe through essence, presence or imagination, [the painter] has it first in his mind and then in his hands, and these are of such excellence that they can generate a proportional harmony in the time equivalent to a single glance, just as real things do". The

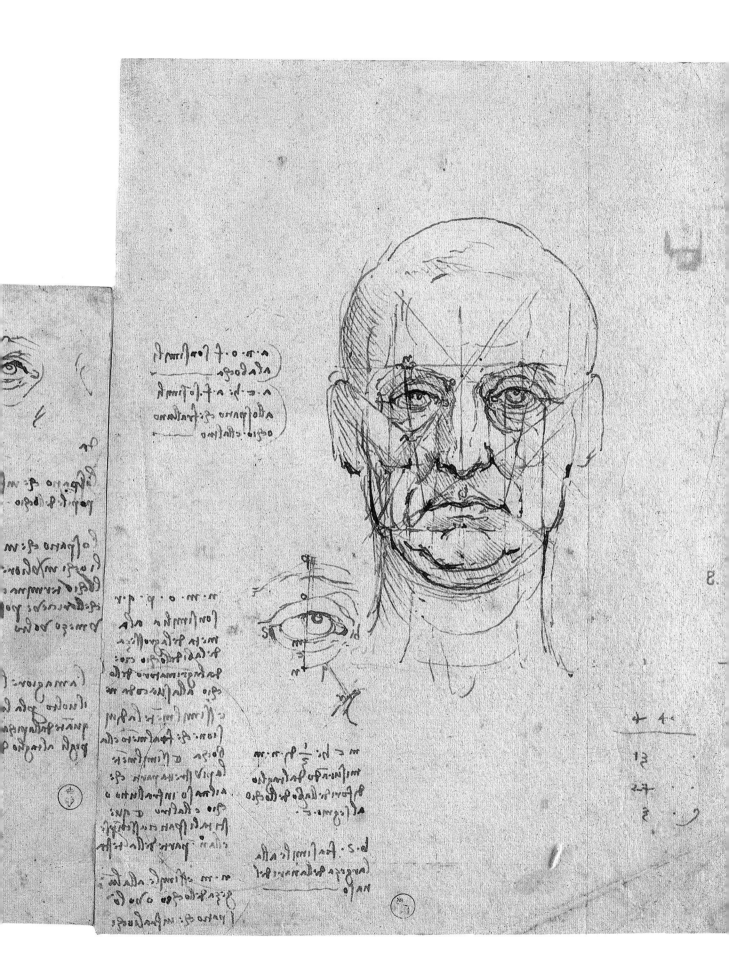

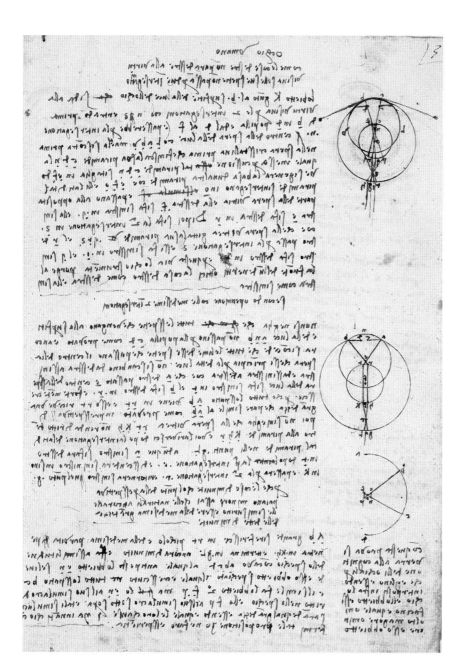

46. *Studies and diagrams of optics*, c. 1508–9, pen and ink on unprepared paper, 22.3 × 15.9 cm. Paris, Bibliothèque de l'Institut de France, Ms D (2175), fol. 3 recto.

47. *Portrait of a Milanese Lady (La Belle Ferronnière)*, c. 1493–6, oil on walnut panel (single board), 63 × 45 cm. Paris, Musée du Louvre, inv. 778.
Perhaps requisitioned by Louis XII by the end of 1499, it is assumed that this should be identified as the portrait of an Italian lady recorded in the Chateau d'Amboise on 24 July 1500 among the belongings of Anne of Brittany; apparently recorded in the royal residence in Blois in October 1517, when it was described by Antonio de Beatis as "a picture in which a Lombard woman of innate beauty is painted in oil", it was later confused firstly with the portrait of a duchess of Mantua (1642), and then, due to an inventory error (1709), with the mistress of François I, known as *La Belle Ferronnière* as she was the wife of an ironware merchant (*ferronnier*). The sitter, however, should be identified as Lucrezia Crivelli, lady-in-waiting to Beatrice d'Este who became il Moro's mistress in 1493, giving birth to a son in 1497 (a sonnet in her praise, attributed to the poet Antonio Tebaldeo, is found on fol. 456v of the Codex Atlanticus). Emphasizing the sculptural pose diagonally in the space and rendering her gaze fleeting and elusive, Leonardo represents her as though totally enveloped in her own indefinable detachment, which nevertheless exerts a subtle fascination on the viewer. Restored by Agnès Malpel and Juliette Mertens in 2014–15.

painter's strength, therefore, resides in his ability to contemplate, in *essence*, *presence* or *imagination*, the universe in its entirety (that is to say, not only in its external *presence*, but also in its inherent and abstract *essence* and even according to the pure fiction of an *imagination* of it produced by the mind), passing from the "beauties with which he becomes enamoured" [47] to "monstrous things that frighten" [48] "or that may be amusing or ridiculous" [49] "or truly compassionate" [50].

The re-creation of a 'second nature' is made possible by that very passage from *mind* to *hand* (in which the two complementary acceptations of the painter's profession, conceptual and hand-crafted, combine), admirably implemented through the use of drawing that may be considered as Leonardo's 'representational language'. In fact, in drawing the images materialise and reveal themselves in the instantaneity and development of their own production in the mind. Drawing, therefore, is not only (and not so much) the concrete and material graphic medium through which to confer representation on what is observed, in the potentially immense compilation of an inventory of the knowable or, as has also been claimed, of an 'archive of visibility'; but also and (above all) a complete project of inquiry and interpretation, of the external universe, as well as the inner world of the artist-scientist.

"You will ensure that with drawing you show to the eye the intentions and invention that has developed in your imagination" (ibid., §76): the precept reconstitutes in indissoluble unity the applications dictated to drawing by "intention" and "invention",

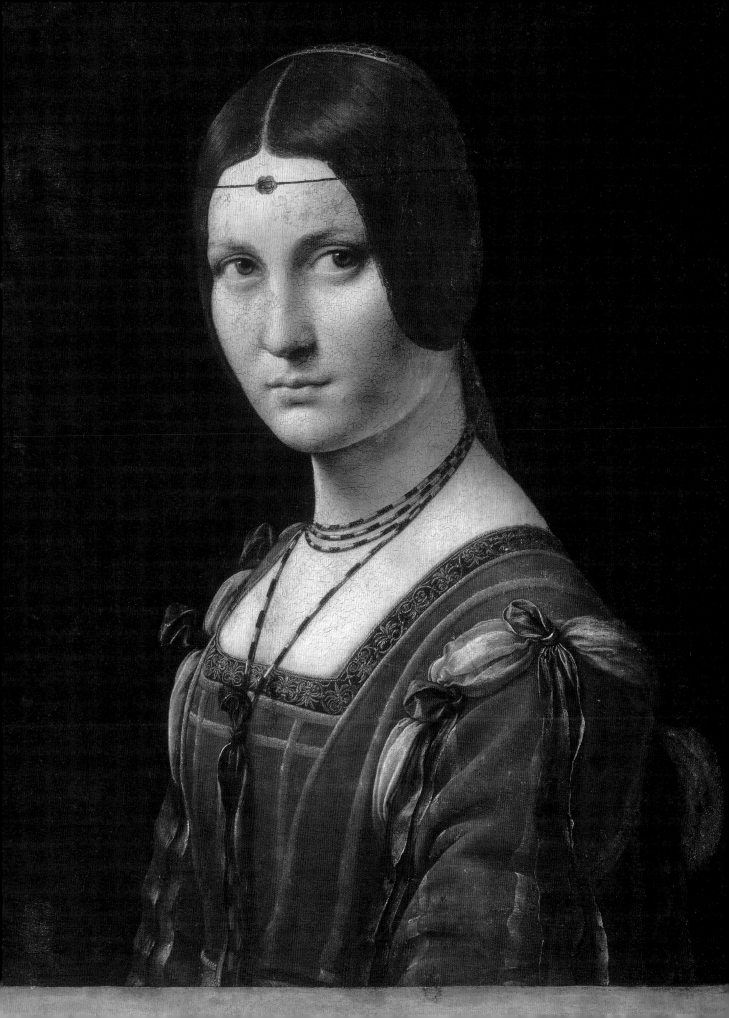

48. Study of 'scythed chariots', c. 1485, traces of metalpoint, pen and brushed ink on unprepared paper, 21 × 29.2 cm. Turin, Biblioteca Reale, inv. 15583.

The drawing seems to offer a visual counterpart to the shocking reference to "safe and unassailable chariots, which bursting amongst the enemy with their weapons, would outperform any army no matter what its size", promised to Ludovico il Moro in the letter of presentation of 1482 (Codex Atlanticus, fol. 1082r). Further confirmation of the antiquarian nature of the studies of the military arts carried out during Leonardo's early years in Milan, the invention of the so-called 'scythed chariots', described by Vegetius in *Epitoma rei militaris* (III, 24), is also found in Book X of the vernacularisation by Paolo Ramusio of Roberto Valturio's *De re militari*, published in 1483, which Leonardo would certainly have known. The macabre representation of the lifeless bodies of the enemy, whose limbs severed by the rotating scythes attached to the war chariot are strewn on the ground in a spectacular demonstration of the fearsome nature of the military invention, constitutes a personal addition by Leonardo.

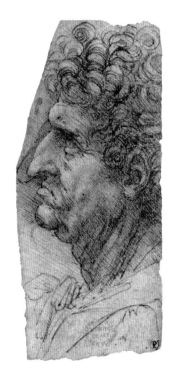

49. Study of 'caricatured' male profile, c. 1490–4, traces of black chalk (or charcoal), pen and brown ink on unprepared paper, 11.7 × 5.2 cm. New York, The Metropolitan Museum of Art, Rogers Fund, inv. 1909.10.45.1.

Drawing on Verrocchian-inspired martial iconography (for example, the equestrian monument to Bartolomeo Colleoni in Venice) but also an awareness of classical coinage bearing the portraits of Roman emperors such as Galba and Nero, Leonardo accentuates some characteristic features (particularly the aquiline nose and the jutting lower lip) to produce a derisory 'caricatured' variant of that illustrious heroic model. The artifice is more evident still in the initial profile, drawn where the left-leaning diagonal hatching can now be seen, intended to denote the shading in the background against which the figure stands out: characterised by an almost grotesque deformation of the protuberances of the nose and chin, this first version of the face was then abandoned in favour of the present and more moderate one.

A recent proposal has linked this work to the
founding of an Hieronymite monastery in Pavia,
which took place in 1481: it would thus be the
first commission undertaken by Leonardo after his
arrival in Milan but then interrupted in 1483, when
he turned his attention to the more demanding
task of the altarpiece for San Francesco Grande.
Indeed, "some St Jeromes" appear in the list of
works drawn up before the journey from Florence
to Milan (Codex Atlanticus, fol. 888r), testifying
to the existence of drawings or sketches (also in
clay) deriving from the corresponding Verrocchian
models, to which this unfinished painting is similar,
particularly in the exaggeration of its expressive
pathos. The articulated pose of the saint, with the
limbs reaching into the space as though measuring
its dimensions, is adapted with several variations
in the figure that personifies Geometry in the short
treatise in verse *Antiquarie Prospettiche Romane*
(1498), dedicated to Leonardo by a 'Prospectivo
Melanese Depinctore' [Milanese painter expert in
the use of perspective] (sometimes identified as
Bramante, his friend and colleague at the Sforza
court). Restored by Gianluigi Colalucci in 1993.

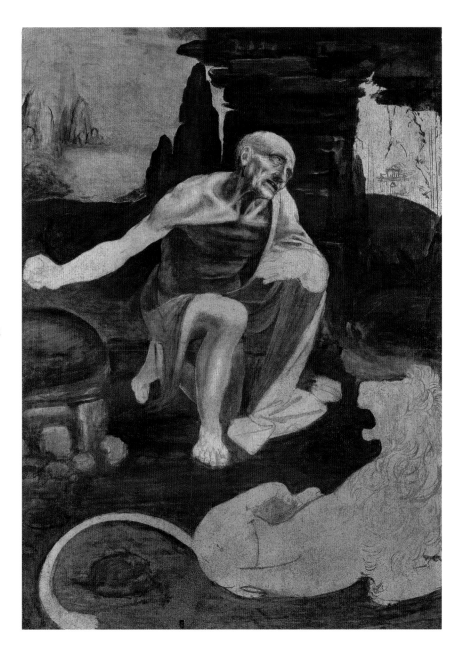

which, as expressions respectively of desire and creativity, are both fruits of the "imaginative", that Leonardo considered coincident with the idea produced in the mind. Human intellect, in his opinion, is in fact subdivided into three faculties, corresponding anatomically to the same number of cerebral ventricles: *imprensiva* (the first to receive the sensorial stimuli), *common sense*, *memory*. The perception of reality that originates from the senses (primarily from sight) is thus submitted to a mental elaboration provided by the consequential participation of these three faculties but it is specifically the imaginative, "rudder and bridle of the senses", that

oversees them (Windsor, Royal Library, inv. 19019 verso). Inherent to common sense, and originating from it, through the impulse of *intention* and *invention*, are the forms that the drawing might represent so that, in a virtuous cognitive circuit, the eye might in its turn then appreciate, also in this graphic reconstruction, the "demonstrative form". The 'drawing of the world', therefore, should be intended as its *design*, in the sense of not being confined to its specular and mimetic replication, being able instead to translate it into a conceptual and aesthetic reconfiguration, through which the artist can reinterpret and reinvent the natural world.

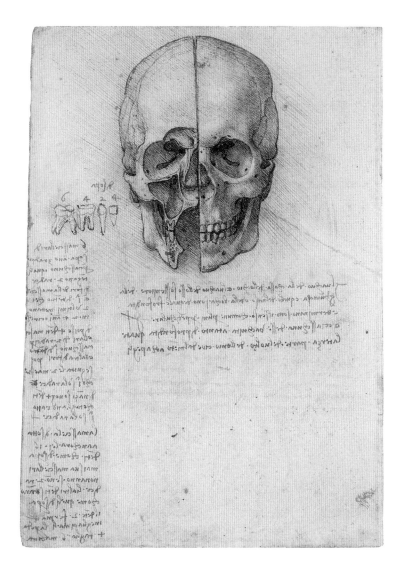

51. *Study of the human skull sectioned*, 1489, traces of black chalk (or charcoal), redrawn in pen and ink, on unprepared paper, 19 × 13.7 cm. Windsor, Royal Library, inv. 19058 verso.
On the left, the sheet also includes a classification of the teeth, on the basis of their number, the type of root and the years of their development. It forms part of a series of similar studies of cranial osteology, the first of which (Windsor, Royal Library, inv. 19059 recto) bears the fundamental annotation: "2 April 1489, book entitled de figura humana" (indicating the artist's intention to produce an anatomical treatise). The main theme of this spectacular virtual dissection of the skull is the search for the seat of the principal cerebral faculty, "common sense", which Leonardo, in a radical take on a concept that went back to Artistotle's *De anima* (III,2) considered essentially coincident with the intellectual mind, in that it was the point of convergence of the sensory perceptions.

Sight, however, was not seen by Leonardo simply as a mere sensorial intermediary. Consider his proud defence of painting, consigned to the so-called *Paragone* or *Comparison of the Arts* (which occupies the first part of the *Treatise on Painting*) and entrusted to an exacting assertion of its scientific value, since it was founded on mathematical, geometric and philosophical assumptions, as it produces the configuration of a conception of man and the world, in addition to their representation. In Leonardo's view, painting deserved to be elevated to the rank of the 'liberal' arts, rather than being considered a 'mechanical' art, that is to say purely manual and handcrafted. For the purpose of proving its superiority compared to poetry, Leonardo resorts to "such a relationship between the science of painting and poetry as that which exists between the body and the shadow it projects", observing that "the shadow of a body at least enters the *senso comune* through the eye, while the imagined form of the body does not enter through this sense but is born in the darkness of the inner eye (*occhio tenebroso*)" (*Treatise on Painting*, §15). Both disturbing and sublime at the same time is this connotation of lights and darks (*chiaroscuro*), of the *occhio tenebroso* in which the *imagination* of things is generated, as though it were a specular

double of the eye itself, assigned to an exact and mimetic assimilation of the true vision of them, before then retransmitting to the *senso comune* (seat of the intellectual mind, to the location of which the celebrated studies of skulls made starting in 1489 were principally devoted; [51]) In fact Leonardo stated "O che differenzia è a imaginar tal luce in l'occhio tenebroso, al vederla in atto fuori delle tenebre" (ibid.), meaning that the sight can perceive 'in action' (ie. with immediacy) the light of truth, while the imagination remains confined to the shadows, observed by that inner eye immersed in the darkness of the mind.

To this form of imagination active in the awakened intellect of the painter, Leonardo was then to add (and in a certain sense contrast) the imagination as a fertile source of oneiric inventions, that is to say originating during sleep from dreams: "a thing is seen by the eye in dreams more clearly than it does with imagination when awake" (Codex Arundel fols. 278v–271r, *c.* 1503–4). This moving thought betrays the seemingly paradoxical conviction that what is "seen" while dreaming is more true than what can be imagined while awake, because the *occhio nei sogni* (eye in dreams) offers painting (not only as a form of artistic expression but also and above all as the model and instrument

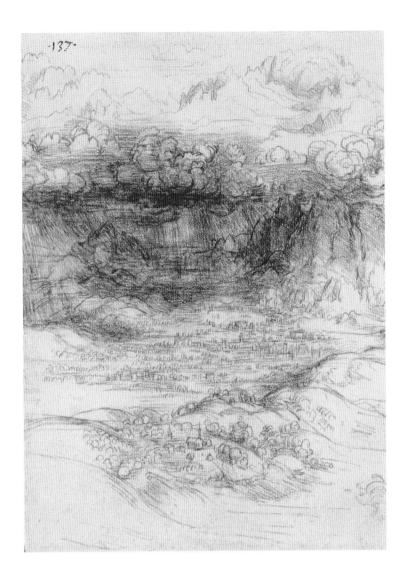

52. *Storm in an Alpine valley*, c. 1506–8 or later, red chalk on unprepared paper, 19.8 × 15 cm. Windsor, Royal Library, inv. 12409.

In the letter dedicating *The Prince* (1513) to Lorenzo di Piero de' Medici, Niccolò Machiavelli adopted the fascinating metaphor of a landscape which seems to find an echo in the flowing projection of the gaze suggested by this sweeping bird's eye view of an Alpine valley. Perhaps it shows a section of the Valtellina, which Leonardo visited during the time he spent in Milan: "Just as those who draw landscapes remain on the plain in order to survey the nature of the mountains and places that are situated high up, to comprehend fully the nature of people, one must be a prince, and to comprehend fully the nature of princes one must be an ordinary citizen". Machiavelli thus compares a desirable flexibility in the choice of perspective in political observation to the skilful mastery of space demonstrated by a draughtsman of landscapes, figure in which Leonardo, who he had met in Cesare Borgia's entourage in 1502, is called to mind. The heavy clouds gathering menacingly on the mountain tops, twisting their own stormy nimbuses, seem to represent an immediate and direct prelude to the late series of the *Deluges*, allowing the dating of this drawing to be extended to the middle years of Leonardo's second Milanese period.

of knowledge) a third way of perceiving "the true likeness of your idea" (in other words, the simulacrum of the intellect). This, with greater truth than the poet, can be offered by the painter, particularly, to the *amante* who has chosen the locations of nature – "sites in which are situated rivers, woods, valleys and countryside" [52] – as representative of his "past delights" (*Treatise on Painting*, §18), desiring thereby to allude, in a broad (and autobiographical) way, to the feeling of love for nature and the pleasure that derives from knowledge of it.

It is significant that this theoretical conception of the art of painting should find full and eloquent expression in his late paintings. In these, especially as far as the rendering of the natural landscape and of the human figure's total immersion in it is concerned, Leonardo seems to take up in an ideal way the challenge of Apelles' legendary ability (recounted by Pliny in *Historia Naturalis*). He aims at representing even the seemingly invisible forms of nature: the extemporary turbulence of the elements, entrusted to the vitality and transmutation of atmospheric agents, and the fluidity of time itself that fragments and consumes the world. The flattering comparison with the artist from antiquity had already established Leonardo's fame and

success at the Sforza court: the first known printed reference to him, in the poet Bernardo Bellincioni's *Rime* (published in 1493) transforms him into a Florentine Apelles in a sort of anthology in verse of Milan as the new Athens ("from Florence a new Apelles has been brought here", specified in a note in the margin by the publisher Francesco Tanzi: "Magistro Lionardo"). The same comparison is repeated in a recently rediscovered later source, an edition of Cicero's *Epistulae ad Familiares* (Bologna, 1477), by 1493 in the possession of Agostino Vespucci (a pupil of Poliziano, Machiavelli's assistant and a direct acquaintance of Leonardo) and densely annotated by him over a long period of time (University Library, Heidelberg). Here (fol. 11a), opposite Cicero's mention of Apelles' lost (and unfinished) *Venus*, we find the following dated annotation:

Apelles pictor. Ita Leonardus Vincius facit
in omnibus picturis suis, ut enim caput
Lise del Giocando et Anne matris virginis.
Videbimus quid faciet de aula magni consilii,
de qua re convenit iam cum vexillifero. 1503 octobris

So, to an eyewitness, in the autumn of 1503, the *Mona Lisa* [53] and *St Anne* [54] thus appeared as two works only recently begun. Leonardo had in fact returned to Florence in March of that year, after having worked in the service of Cesare Borgia in the Marche and Romagna as a military engineer from the summer of 1502. The only part of both paintings to be completed at that time was the head, thus compared to what Cicero had written regarding Apelles' masterpiece ("caput et summa pectoris politissima arte perfecit, reliquam partem corporis inchoatam reliquit"). It is not unlikely that Vespucci, on diplomatic service in Milan from 1495 to 1499, was aware of the association between Leonardo and Apelles then in vogue. To this, further accolades would soon be added, referring to illustrious personalities, also in an elaborate tribute to his scientific skills (such as "Archimedeo ingenio notissimus", praise bestowed upon him by Pomponius Gauricus in *De sculptura* of 1504). Nor can it be excluded that Leonardo himself, being aware of Pliny's text, might have favoured the spreading of this *topos*, with the aim perhaps of ridding himself of the not infrequent accusations of lack of effectiveness in his activity as a painter: according to Vasari, even during his later years in the Vatican from 1513 to 1516 in the entourage of the Duke of Nemours, brother of the Medici Pope Leo X, he aroused the indignation of the pope, driven to exclaim: "Oh dear, this man will never do anything. Here he is thinking about finishing the work before he even starts it!".

The final annotation in the Heidelberg volume relates to the *Battle of Anghiari*: in a tone of barely concealed irony and with prophetic perplexity, Agostino suspends any judgement on the incipient and ill-fated mural painting for the Sala del Maggior Consiglio in Palazzo Vecchio ("Videbimus quid faciet de aula magni consilii", that is to say 'Let's see what he makes of the sala del gran consiglio'), stating that he is aware of the agreement already reached between the artist and the gonfaloniere Soderini ("de qua re convenit iam cum vexillifero", namely 'which he has already agreed with the standard bearer', ie the Florentine *gonfalone*), who had in fact granted him on 24 October 1503 access to the Sala del Papa in Santa Maria Novella in order to begin work on the preparatory cartoon. Only a few sketches from this now survive, but are capable nevertheless of transmitting to us something of the virulent and explosive energy released by the inextricable tangle of human bodies and horses around the pole bearing the contested standard [55–6].

The drawings of the *Deluges*, often considered in some ways Leonardo's intellectual and artistic testament, aim to convey by means of drawing the diagrammatic visual representation of what was by then the unleashed and uncontrollable dynamism of the natural elements, presenting a visualisation so hyperreal as to appear at times artificial and intellectualising. In the late landscapes of the *Mona Lisa* and *St Anne*, however, Leonardo resorts instead to ineffable representations of the metamorphic vitality of the natural world, perceived as an entity in perennial and continuous transformation in the millennial scansion and succession of chronological eras. The rocks of a crumbling consistency, the summits of the mountains jagged and eroded, the calm stretches of water, which inexorably flow from them, the mists with their vapours of the condensation of the beginning (or end) of time seem deceptively to be captured in their vital essence, thanks to two formidable pictorial 'inventions'. On one hand, *prospettiva aerea* gives rise to what Leonardo would refer to as chromatic *perdimenti*: sensitive to the apparent dissolving of colour through the gradual interposition of atmospheric filters stretching towards the horizon, the expedient allowed "the things we see furthest away in the air, such as the mountains, due to the great quantity of air that lies between the eye that perceives and the mountain itself, makes the mountain seem blue, the same colour as the air" (*Treatise on Painting*, §262). And on the other, *sfumato* removed the sharpness of the form and outlines of the body, allowing the human figure, thus lacking even the most infinitesimal diaphragm, to make itself immersively part of the natural macrocosm, making it possible that "your shadows and your highlights may be joined without separating lines, as though made of smoke" (ibid., §70). Trained in his youth in the rigour and perfection of the primacy of drawing (which in the *Deluges* is taken to a formal intensity in which naturalistic certainties crumble), in his final years, Leonardo understood that the pictorial artifice of complete verosimilitude needed to avail itself of an illusory elimination of *lines and marks*, so that art might generate the union of *light and shadow* in a 'sfumata' continuity of passages, "as though made of smoke".

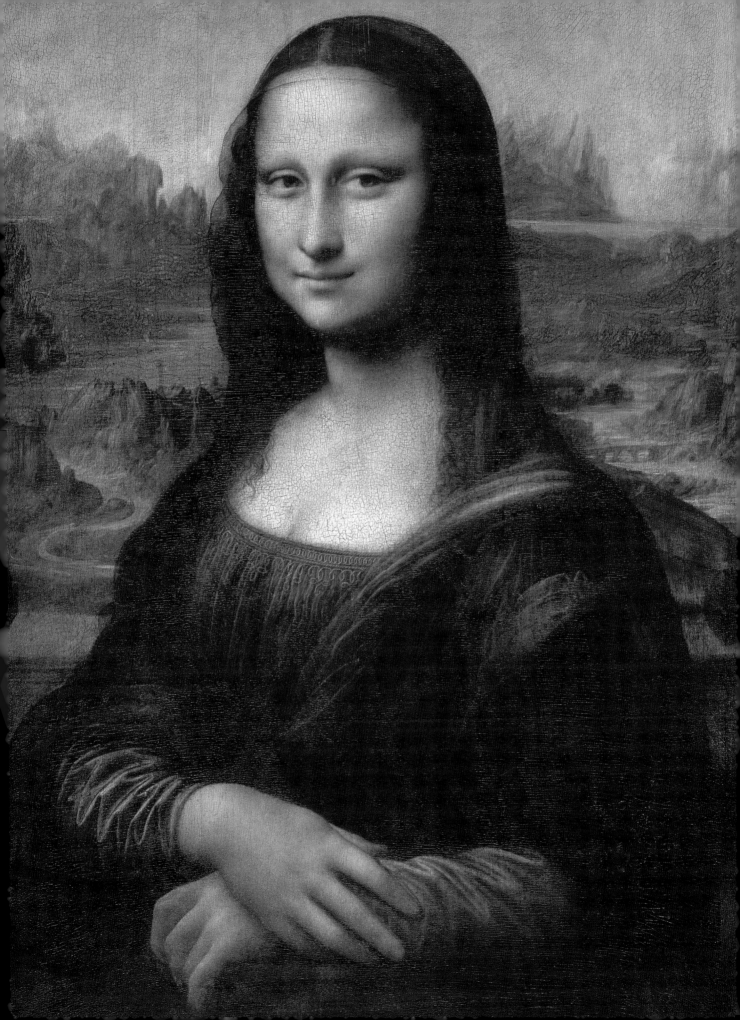

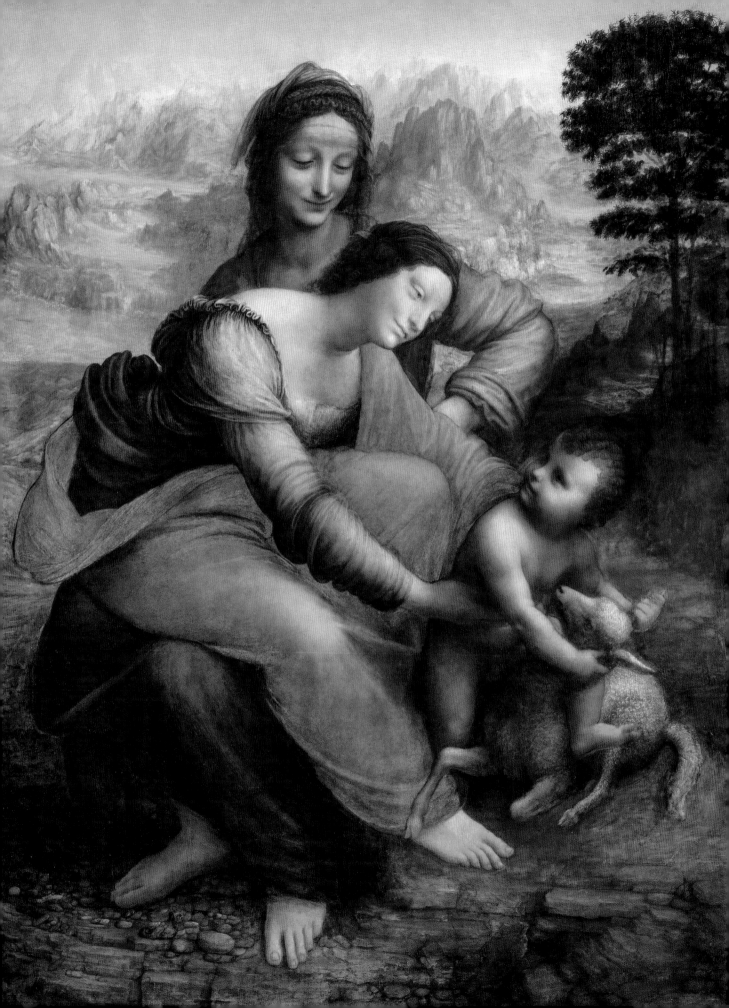

**54. St Anne, the Virgin and Child with a lamb,
c. 1503, 1508–10 and later, oil on poplar panel
(four boards joined vertically), 168.4 × 113 cm.
Paris, Musée du Louvre, inv. 776.**
In October 1517, the panel is recorded as "a Virgin
and Child who are seated on St Anne's lap" in the
handwritten diary of Antonio de Beatis, secretary
to Cardinal Luigi d'Aragona, who was visiting the
manor at Cloux where Leonardo had established
his final residence as the guest of François I.
Paolo Giovio (1525) and the Anonimo Gaddiano
(c. 1540) also both confirm the painting's arrival
in France and its subsequent acquisition by the
king. Leonardo must have started working on
the painting again (and it remained unfinished in
several areas at his death) in Milan in 1506–8,
for Louis XII: it might in fact correspond to one of
the "two paintings of our Two Ladies [the Virgin
and St Anne] of various sizes, which have been
made for our most Christian king". These were
mentioned in two of his drafts for letters in the
spring of 1508 addressed to Charles d'Amboise,
governor of Milan on the king's behalf (Codex
Atlanticus, fols. 872r and 1037v). Restored by
Cinzia Pasquali in 2010–12.

**55. Studies for the 'Battle of Anghiari': sketch
of skirmishes between horses and footsoldiers
for the 'Fight for the Standard', c. 1503, traces
of black chalk, pen and ink on unprepared paper,
16 × 15.2 cm. Venice, Gallerie dell'Accademia,
inv. 215 recto.**
The contract for the wall painting for the Sala del
Maggior Consiglio in Palazzo Vecchio, bearing
the date 4 May 1504 and allocating the work to
Leonardo, was undersigned by Niccolò Machiavelli
as legal witness, and was to represent a significant
episode in the history of the Florentine Republic:
the victory scored over the Milanese army (aided
by mercenary soldiers from Perugia) on 29 July
1440 at Anghiari, near Arezzo, in coalition with the
Papal troops. An account of the battle, taken from
Tropheum Anglaricum by Leonardo Dati (1443),
was transcribed by an assistant of Machiavelli and
an acquaintance of Leonardo, Agostino Vespucci,
on both sides of fols. 202a and 202b of the Codex
Atlanticus. On 24 October 1503, Leonardo was
given the keys of the Sala del Papa in Santa Maria
Novella so that he could prepare there the great
cartoon. An annotation in Leonardo's hand dated
6 June 1505 (Codex Madrid II, fol. 2r) provides
autobiographical evidence that he had by then
begun to "paint in the palace".

**56. Studies for the 'Battle of Anghiari': sketch
of skirmishes between horses and footsoldiers
by a bridge, for the 'Fight for the Standard', detail,
c. 1503, pen and ink wash on unprepared paper,
10 × 14.2 cm (whole sheet). Venice, Gallerie
dell'Accademia, inv. 216.**
Leonardo worked on the vast wall painting
(whose measurements have been estimated as
approximately 18 metres wide and 8 metres high)
until May 1506, but by 9 October the *gonfaloniere*
Pier Soderini was complaining in a letter to his
French patron in Milan, Charles d'Amboise, that
the artist had only "made a small start on the
great work that he was to execute". The reason
for the interruption of the work was blamed by the
Anonimo Gaddiano (c. 1540) on the negative results
of the use of the encaustic technique on plaster
described by Pliny, while other contemporary sources
attributed the failure to the supply of poor materials
(Antonio Billi, c. 1515) or to a defect in the plaster
(Paolo Giovio, 1525). What remained of Leonardo's
ruined effort was covered during the time of the
Grand Duchy by fresco decorations executed by
Giorgio Vasari in his radical and also architectural
refurbishment of the chamber, renamed Salone del
Cinquecento (1557–63).

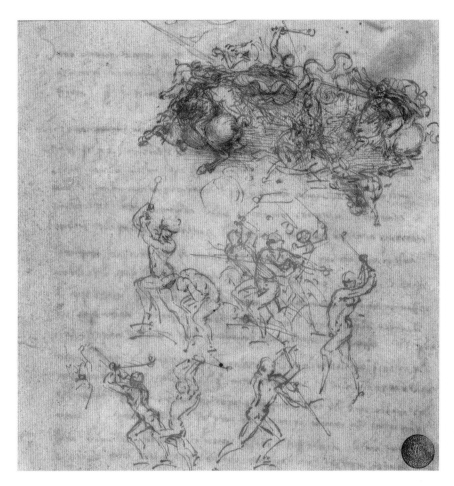

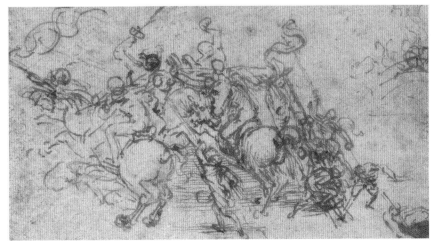

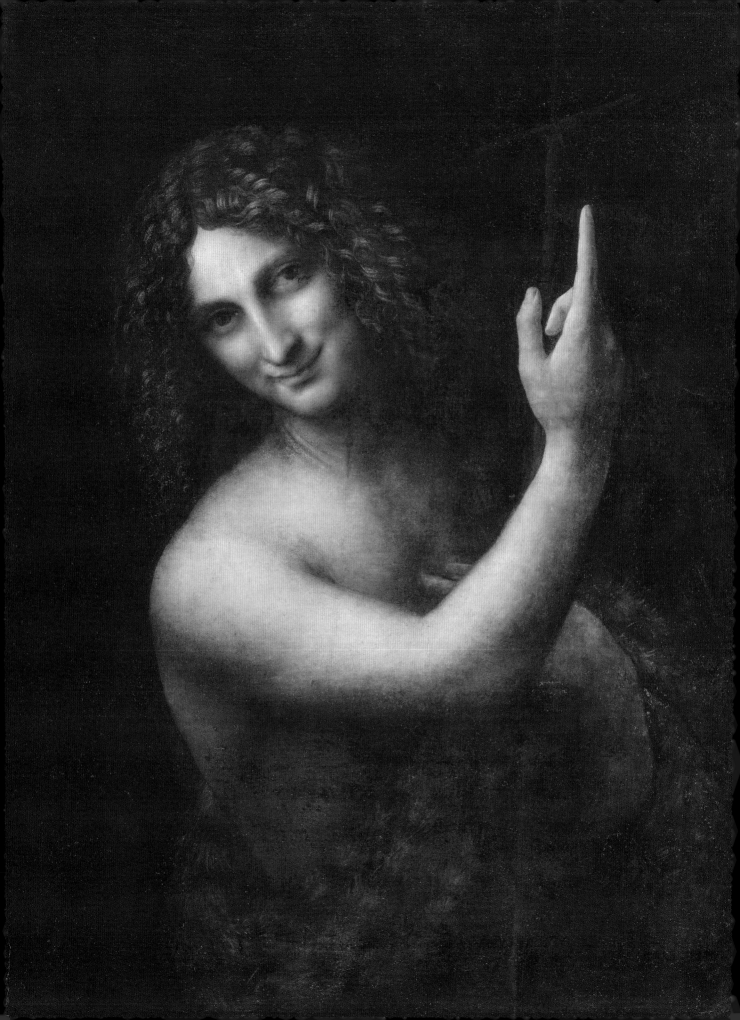

57. *St John the Baptist*, c. 1506–13 (and later?), oil on walnut panel (single board), 73 × 56.5 cm. Paris, Musée du Louvre, inv. 775.

Although it has been suggested that the work was commissioned by Giovanni Benci (a Florentine friend of Leonardo) around 1506, a charcoal drawing by a pupil of the Baptist's pointing hand on fol. 489r of the Codex Atlanticus provides evidence of the painting's presence in Leonardo's workshop and of its slow execution during his second period in Milan. The drawing is referable to 1509 due to an indisputable series of links with other sheets whose date can be securely established. The iconography is partly in keeping with that adopted by Giovan Francesco Rustici in the *Preaching of the Baptist* for the Baptistery in Florence and, according to Vasari, Leonardo participated in the creation of its model in terracotta (a circumstance that must have occurred in the spring of 1508, when, having returned temporarily to Florence, he had shared lodgings with his sculptor colleague in the home of Piero di Baccio Martelli). Restored by Regina Moreira and Patrick Mandron in 2016.

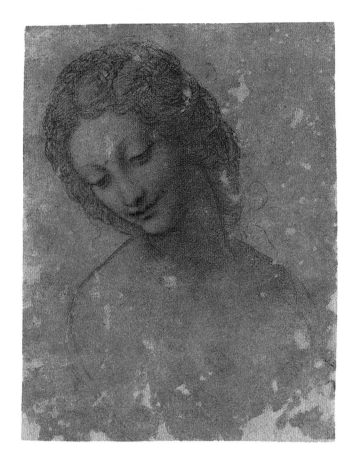

58. Leonardo (?) and pupil (Francesco Melzi?), *Study for the head and bust of 'Leda'*, c. 1506–8 or later, red chalk on traces of black chalk on pale red prepared paper, 20 × 15.7 cm. Milan, Castello Sforzesco, Civico Gabinetto dei Disegni, inv. 3805 bis B 1354.

The drawing, whose precarious state of conservation has recently been rectified thanks to careful restoration by the Opificio delle Pietre Dure (2014), conveys the sensitive expression on the inclined face of the Trojan princess, whose slightly twisting torso is captured in the restrained sensuality of her nakedness. The attribution to Leonardo, albeit in collaboration with one of his pupils (probably Melzi), has often been contested, but seems likely due to the delicate nature of the lines that describe the locks of the plaited hair and for the left-leaning direction of the velvety shading around the neck. A lost cartoon for *Leda*, given in 1585 by Orazio Melzi to Giovan Ambrogio Mazenta, then came into the hands of Pompeo Leoni, who unsuccessfully attempted to sell it to the Grand Duke of Tuscany in 1614; it then belonged to Galeazzo Arconati (and is recorded in 1671 in his villa at Castellazzo), and was mentioned for the last time in Milan in the Casnedi collection in 1721. The Milanese origin of the work might be confirmed by an annotation of c. 1508 relating to a possible female model found in the Pusterla dei Fabbri near Porta Vercelliana: "women of Messer Iacomo Alfeo and Leda in the Fabri" (Windsor, Royal Library, inv. 19095 verso).

Agostino Vespucci's testimony is vital in offering an indisputable chronological footing at least for the dating of when the works were started, both of them destined however to accompany the artist right up to the final three years of his life in France. From another essential account (the diary of Antonio de Beatis, who visited Cloux in the autumn of 1517 with Cardinal Luigi d'Aragona), we know that in his final home in Amboise as the guest of the French king François I, Leonardo had with him *tre quadri perfectissimi*. Two of these can probably be identified as the *Mona Lisa* and *St Anne*, while the third was undoubtedly *St John the Baptist*, now, like the others, conserved in the Louvre [57], the male counterpart to the pagan nudity of *Leda*, a lost work of which only pale imitations and some refined drawings remain, at least hinting at its grace and beauty [58], but also the symbolic personification of the generating forces of surrounding nature [59–60]. Irreverent and faun-like, this florid youth (so far-removed from the tradition of the emaciated adolescent in the wilderness) displays all the provocative seduction of an ambiguous charm. This is due not only (and not so much) to the intentional sexual ambiguity (with an exuberance expressed in the hydromorphic cascade of the curls on his head), as to the implicit message in the flirtatious gaze obliquely directed at the viewer, in the knowing complicity of the smile, and, finally, in the pointing gesture that marks the culmination of the spiral movement of the entire body, as though in a Dionysian dance, directed towards an indefinable obscurity.

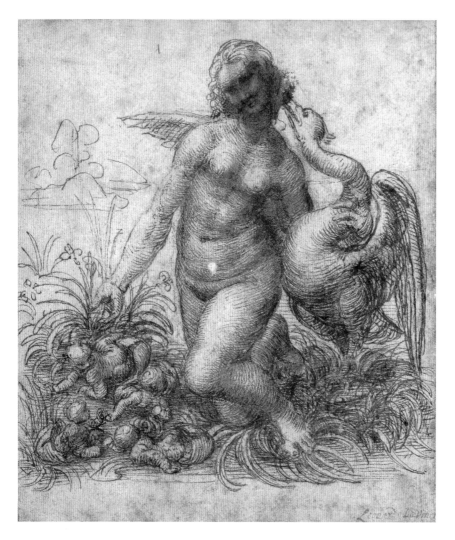

59. *Study for a kneeling 'Leda'*, c. 1506–8, black chalk, pen and brown ink on unprepared paper, 16 × 13.9 cm. Chatsworth, Devonshire Collection, inv. 880/717.

This variant seems to derive from a classical sculptural model (a female figure crouching on a tortoise) which Leonardo might have seen in the spring of 1501, when he visited the antiquities of Rome and Tivoli (Codex Atlanticus, fol. 618v), or slightly earlier in Mantua, during the winter of 1499–1500, through the direct contemporary copy made of it by Pier Jacopo Bonacolsi (known as Antico) kept by Ludovico Gonzaga in the castle at Bozzolo. The presence of three sketches of a woman apparently kneeling beside an egg from which a putto is emerging, on a sheet in Windsor (RL 12337r), also containing a study for a rider relating to the *Battle of Anghiari* (c. 1503), has suggested that this version must have preceded the other (standing), which, prepared as a cartoon between 1504 and 1506 (when it was seen and copied by Raphael in Florence), then resulted in the painting mentioned for the first time at Fontainebleau by Giovan Paolo Lomazzo in 1590, but lost or destroyed between 1694 and 1775.

60. *Study of marsh flowers: anemone and calendula*, c. 1505–10, traces of black chalk, pen and ink, on unprepared paper, 8.5 × 14 cm. Windsor, Royal Library, inv. 12423.

The attention bestowed by Leonardo on the watery setting of the banks of the Eurota river (where, according to legend, the encounter between Leda and Jupiter in the guise of a swan took place), in which marsh plants and flowers proliferate like those depicted in this drawing and also in that in Chatsworth [fig. 59] throughout the entire composition (in which the grasses and leaves assume a serpentine sinuosity), has recently enabled Pietro C. Marani (2018) to establish a link with the celebrated *Hypnerotomachia Poliphili* (Venice 1499). There, referring to the four theogamies corresponding to the four natural elements, the union of Leda and the swan had assumed the symbolic meaning of the element of water and its generative properties, eloquently illustrated also by the prodigious birth of the two eggs, each containing a pair of twins (Castor and Pollux, Helen and Clytemnestra).

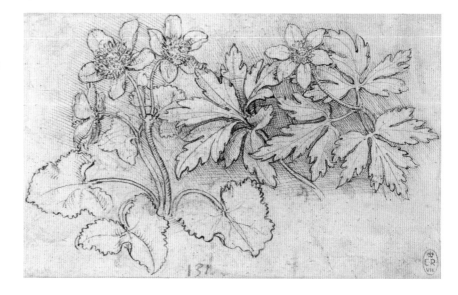

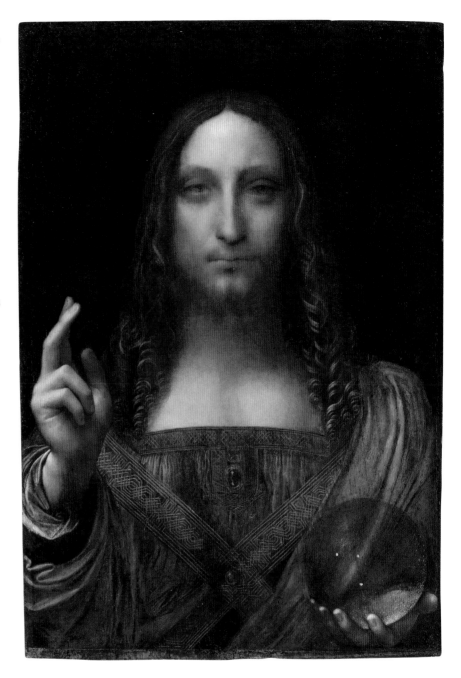

61. *Salvator Mundi*, 1495–9 and later (1508–13), oil on walnut panel (single board), 65.5 × 45.1 cm. Collection of the Saudi Prince Mohammed bin Salman, present whereabouts unknown (destined for the Louvre, Abu Dhabi).

Exhibited in world preview at the National Gallery in London in the winter of 2011–12, it was sold at Christie's on 25 November 2017 for the record amount of 450 million dollars. The painting came from the prestigious collection of Sir Francis Cook in Richmond, who had acquired it in 1900 as a modest copy. In 2005, it was with Robert Simon, a New York art dealer, where it underwent cleaning and restoration by Dianne Dwyer Modestini between 2008–11. A layer of painting emerged, seriously damaged in several areas, revealing in others, however, incomparable skill: notably, in the articulation of the blessing gesture of the right hand and in the skilful rendering of the sphere of rock crystal held in the left. The existence of a *Salvator Mundi* painted by Leonardo has been known since 1650, thanks to an engraving made by Wenzel Hollar, with which it was already possible to associate various workshop copies. Two hypotheses surround the political circumstances that might have given rise to its commission: either at the request of the Republic of Florence (perhaps at the direct instigation of Savonarola), in celebration of the expulsion of the Medici on 9 November 1494 (a day dedicated to the Saviour), or at the behest of the king of France, Louis XII, from 1499, but more likely around 1508–13, during Leonardo's second sojourn in Milan.

As though in a disturbing self-portrait, Leonardo seems to assign to the Precursor, almost adopted as a specular image of himself, a final message of ineffable mystery (in a premonition of the fascination his work was destined to exert in the course of the following centuries). On a sheet dated "Saint John's day 1518" (Codex Atlanticus, fol. 673r), that is to say 24 June (almost exactly a year before his death, which occurred on 2 May 1519), he wrote: "I will continue".

In fact, his myth continues to fascinate today, even becoming a tangible object of worship in the increasingly rare authentic testimonies of his talents that come to light: this is true of the sensational and unexpected rediscovery of his final masterpiece, the *Salvator Mundi* [**61**], in whose crystalline orb (the cosmic symbol of the *sphaera mundi*) the manifold totality of the universe seems to be reflected as though in a divine eye or three-dimensional convex mirror.

Table of contents

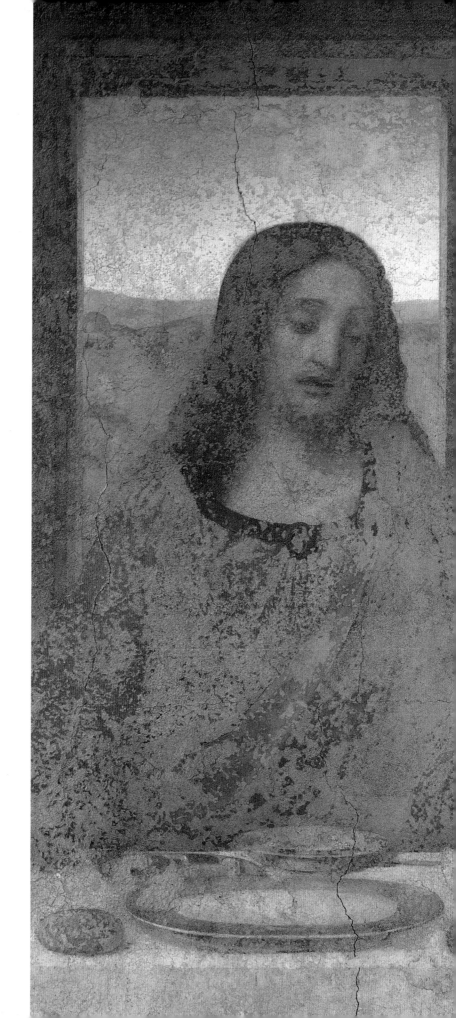